# MRS DALLOWAY

by Virginia Woolf
adapted by Hal Coase

A Forward Arena and Arcola Theatre co-production

**Direction** Thomas Bailey
**Artistic Direction & Design** Emma D'Arcy
**Costume Design** Louie Whitemore
**Lighting Design** Joe Price
**Sound Design and Composition** Tom Stafford

**Producer** Ellie Keel
**Production Manager** Zara Janmohamed
**Stage Manager** Bex Snell
**Artistic Associate** Rebecca MacDuff

Cast

**Clarissa** Clare Perkins
**Peter** Sean Jackson
**Rezia** Emma D'Arcy
**Sally** Clare Lawrence Moody
**Septimus** Guy Rhys

FORWARD ARENA make theatre that is culturally and politically
awake, without ever forgetting theatre's responsibility to be an
impressive and stimulating feast of liveness.

Hal Coase, Emma D'Arcy and Thomas Bailey first developed *Mrs Dalloway* with the National Youth Theatre REP Company 2017. An early version of the show was performed by this company of sixteen young actors at the Ambassadors Theatre, and we are grateful to each one of them for their invaluable energy and input: Rosella Doda, Mohammed Mansaray, Scott Oswald, Amarah-Jae Harris StAubyn, Eddie-Joe Robinson, Leah Elisabeth Gaffey, Joanna McGibbon, Jamie Rose, Megan Burke, Dougie Wood, Marc Benga, Rebecca Hesketh-Smith, Elizabeth McCafferty, Leo Shirley, Jenny Walser and Curtis Kemlo. We would also like to thank Carrie Cracknell, Anna Niland, Paul Roseby and all at NYT for their faith, guidance and support.

Forward Arena would like to thank the following people for their generous support of this production of *Mrs Dalloway*. We could not have made the show without you.

Marion and Desmond Heyworth
Sally D'Arcy
Ric & Joni Lloyd Bailey
Susan and Henry Nash
Trish and David Lloyd-Blake
Maria Patsalos
Jacquie Dabnor
Joseph Craven
Alison Parsons
Elisabeth Lewerenz
Tim Bano
Sally Davies
Darren Siah
Andrew and Kate Green
Penny Coase
Judith Christopherson
Julie Sturgess
Lara McIvor
Hannah Willmott
Hamish Mackenzie
Susanne Weiszhar
Chloe D'Arcy
Ann Fox
Stephen Kyberd

### Thomas Bailey
### Director

Thomas is joint artistic director of Forward Arena. His directing credits include *The Games We Played* (Theatre503), *Callisto: a queer epic* (Arcola Theatre), *Rehearsing for Planet B* (North Wall Arts Centre), *Romeo and Juliet* (Southwark Playhouse/Tokyo Met), and *The Pillowman* (Oxford Playhouse).

He was awarded the Bryan Forbes Directing Bursary in 2017.

### Emma D'Arcy
### Artistic Director

Emma is an actor, theatre-maker and joint artistic director of Forward Arena. She has designed all of Forward Arena's shows to date, including *The Games We Played*, *Callisto: a queer epic*, and *Rehearsing for Planet B*.

### Hal Coase
### Writer

Hal Coase is a playwright and poet based in Manchester. His writing has been featured and performed at the Arcola, the Pleasance Theatre, Camden People's Theatre, the North Wall Arts Centre, and Ambassadors Theatre. After a sell-out run at the Edinburgh Fringe his first play, *Callisto: a queer epic*, transferred to the Arcola Theatre, London, in October 2016, and returned for three weeks in December 2017. *Mrs Dalloway* was first commissioned by the National Youth Theatre REP Company and first presented at the Ambassadors Theatre in London in December 2017.

### Ellie Keel
### Producer

Ellie is producer for Forward Arena. She became an independent theatre producer after working with Thelma Holt, the Oxford Playhouse and the Cameron Mackintosh Foundation. She now produces new plays independently and with organisations including

Barbican Centre, The Big House, The North Wall, The Pleasance, Up In Arms and Heretic Productions. For The North Wall, Ellie co-founded and produces the annual Alchymy Festival of new plays. With Heretic Productions she co-founded and produces Heretic Voices, a national competition and festival of new plays in monologue form. Her work in London includes Hal Coase's *Callisto: a queer epic*, which transferred to Arcola Theatre from the Edinburgh Fringe, *Home Chat* by Noël Coward at The Finborough Theatre, and *Loose Lips* by Katherine Soper at Stoke Newington Town Hall. Ellie is a director of LGBT+ youth charity Just Like Us, an associate artist of The North Wall, and a trustee of The King's Hall Trust for the Arts. She is the co-founder of Greater Space, a new initiative launching in Autumn 2018 which will support women from underrepresented backgrounds to reach positions of leadership in the arts.

### JOE PRICE
### Lighting Design

Joe trained at the Royal Welsh College of Music & Drama and received the 2015 Francis Reid Award for Lighting Design.

Credits include: *My Name Is Rachel Corrie* (Young Vic), *The World's Wife* (Welsh National Opera), *Conditionally* (Soho Theatre), *Breathe* (Bunker Theatre), *Goldfish Bowl* (Paper Birds), *Heather* (Bush Theatre), *This Perfect World* (Theatre Royal Bath), *GATE* (Cockpit Theatre), *Box Clever* (Nabokov), *Fossils* (Brits off Broadway, NYC), *This Must Be The Place* (VAULT Festival), *Let The Right One In* (Arts Ed*)*, *Magnificence* (Finborough Theatre), *Heads Will Roll (Told by an Idiot)*, *How To Date A Feminist* (Arcola Theatre), *Some Girl(s)* (Park Theatre), *Around The World in 80 Days* (Theatre Royal Winchester), *The Love I Feel Is Red* (Tobacco Factory), *Some People Talk About Violence* (Barrel Organ), *Dry Land* (Damsel Productions), *Alternative Routes* (National Dance Company Wales), *The Duchess of Malfi* (Richard Burton Theatre Company), *Animal/Endless Ocean* (Gate Theatre), and *Y Twr* (Invertigo).

## TOM STAFFORD
**Composer and Sound Designer**

Tom is a music producer and composer from London. After graduating from St. Anne's College, Oxford, Tom has been working primarily in electronic music, and his often industrial, beat-driven scores blend warped samples and acoustic instruments with modular synthesisers. As a producer and songwriter, Tom has worked with a number of chart-topping writers and artists in pop and hip-hop, with upcoming releases from Dan Caplen, Call Me Loop, and Jelani Blackman.

His selected theatre work includes: *Callisto: a queer epic* (Ed Fringe/Arcola, 2016), *Romeo and Juliet* (International Tour, 2015), *Zennor* (North Wall, 2015), and *The Pillowman* (Oxford Playhouse, 2014).

He has also scored a number of short films, including: *The Nightmare on Deskteeth Street* (2017, selected for BFI London Film Festival and Aesthetica Film Festival), *Surfing* (2016, Channel 4 Random Acts), and *Life in Orbit* (2016, London Short Film Festival).

## LOUIE WHITMORE
**Costume Design**

Louie trained at Motley Theatre Design and the Royal Scottish Conservatoire.

She is an OldVic12 2016 finalist and a JMK 2010 finalist. She was Offie Nominated for Best Set Designer for *Miss Julie* and *Tonight at 8.30* at Jermyn Street Theatre. She was also Offie Nominated for Best Costume Designer for *The Daughter-in-Law* at the Arcola Theatre.

Theatre credits include: *Diamond* (Underbelly, Edinburgh Fringe), *Nina's Got News* (Pleasance Dome, Edinburgh Fringe), *Bold Girls*, *Single Spies* (Theatre by the Lake), *Tonight at 8.30*, *Tomorrow at Noon* (Jermyn Street Theatre), *Miss Julie* (Theatre By The Lake/Jermyn Street Theatre), *Stewart Lee: Content Provider* (UK Tour/BBC), *Good Soul* (Young Vic), *The Chair*, *The Minotaur*, *My Father Odysseus*, *Play In A Week* (Unicorn Theatre), *Blythe Spirit* (Drum Theatre Beijing/Chinese Tour), *The Winters Tale* (NAPA Karachi), *Lost Land* (Jenin, Palestine), *Potted Sherlock*

(Vaudeville Theatre/UK Tour), *The Adventure*, *Brittania Waves The Rules*, *Future Worlds* (Royal Exchange Theatre), *Three Birds* (The Bush/Royal Exchange Theatre), *Egusi Soup* (Soho Theatre), *The Daughter-in-Law*, *The Dog, the Night and the Knife* (Arcola Theatre), *Mud* (The Gate), *Shakespeare Untold*, *The Magic Playroom* (UK Tour/Pleasance Theatre), *Let The Right One In* (Arts Ed), *I Am A Superhero* (Old Vic New Voices @ Theatre 503), *Medea*, *The Criminals*, *House Of Bones* (Platform Theatre), *Hamlet*, *Lulu*, *Measure For Measure* (Oval House), *After the Floods* (The Dukes, Lancaster), *Dracula*, *Two Planks And A Passion*, *Summerfolk*, *The Kitchen*, *The National Theatre*, *Black Battles With Dogs*, *Figaro Gets Divorced*, *The Wild Duck*, *The Winters Tale*, *Much Ado About Nothing*, and *The Rehearsal* (Set designs for The Cochrane).

Opera credits include: *Savitri & Der Kaiser Von Atlantis* (Royal Scottish Conservatoire), *Messiah* (Danish Opera/Frankfurt Opera), *Die Zauberflote*, *Dead Man Walking* (Schwerin Opera), *Carmen* (Dorset Opera), *Serse* (Iford Opera), *Banished* (Blackheath Halls), *La Fille Du Regiment* (Diva Opera), and *The Magic Flute*, *Carmen*, *La Boheme*, *Albert Herring*, *Marriage Of Figaro* (Costume design for Co Opera Co).

Dance credits include: *The Nutcracker* (Shanghai Ballet), *Egle, Queen Of The Grass Snakes* (Lithuania National Ballet), *Angelina Ballerina* (English National Ballet), *Choreographics*, *Dance Journeys* (English National Ballet at Sadlers Wells/The Barbican), *Unsilenced* (English National Ballet Youth Company), *Swan Lake*, *Coppelia – My First Ballet Series For English National Ballet* (UK Tour/Peacock Theatre), and *Take Flight* (Royal Opera House/Hull City of Culture opening).

Film and TV credits include: *The First Man (Feature Film)* directed by Hardeep Gianni and *Stewart Lee: Content Provider* (UK Tour/BBC).

## REBECCA MACDUFF
### Artistic Associate

Rebecca has worked with Forward Arena as a production and stage manager on *Callisto: a queer epic* (Arcola Theatre), *Rehearsing for Planet B* (Alchymy Festival), *The Games We Played* (Theatre 503), and *Children and Animals* (Pleasance, Edinburgh).

Producing credits include: *Romeo and Juliet* (Southwark Playhouse/ Tokyo Met) and *The OUDS New Writing Festival 2016* (BT studio).

Other production management credits include: *I Promise Tomorrow I'll Forget Where I Buried It* (Etcetera Theatre) and *The Pillowman* (Oxford Playhouse).

## ZARA JANMOHAMED
### Production Manager

Zara trained at the Royal Academy of Dramatic Art in Stage and Production Management.

Recent work has included Edinburgh Fringe (Mick Perrin Worldwide), RADA Festival, *Dramatic Dining Cabaret* (RADA), *Grotty* (Bunker Theatre), *A Passage to India* (Tour/Park Theatre), *Rotterdam* (RADA), *Easter* (RADA), and *Raising Martha* (Park Theatre).

## BEX SNELL
### Stage Manager

Bex is a graduate of RADA, working as a freelance stage manager.

Bex's recent credits include: *The Mousetrap* (St Martin's Theatre), *Hadal Zone, Reverie* (National Centre for Circus Arts), *The Producers* (Yvonne Arnaud Theatre), *Twelfth Night*, *Taming of the Shrew*, *Merchant of Venice* (Globe Theatre), *Hamlet* (KBTC/RADA). *Albert Herring* and *Lucio Silla* (Buxton Opera House), *Le Grande Macabre* (Barbican Concert Hall), *Deny Deny* (Park Theatre), *The Fairy Queen* (Barbican Concert Hall), and *Billy Elliot* (Victoria Palace Theatre).

Bex continues to work within: theatre, musicals, opera, dance and circus.

## Cast

**CLARE PERKINS**
**Clarissa**

Clare trained at Rose Bruford on The Community Theatre Arts Course.

Theatre Includes: *Emilia* (Shakespeare's Globe), *Genesis Inc* (Hampstead), *The Immigrant* (Hoxton Hall), *Daisy Pulls It Off* (Park Theatre), *Primetime* (Royal Court), *Roundelay* (Southwark Playhouse), *The Convert* (The Gate), *Removal Men* (The Yard), *The House That Will Not Stand* (Tricycle), *Fabulation* (Tricycle), *Welcome To Thebes* (National Theatre), *Mules* (Royal Court), *Meridian* (Contact Theatre), *How To Be Immortal* (Penny Dreadful), *Little Revolution* (The Almeida), *How Long Is Never* (Tricycle), *Our Country's Good* (Nuffield), *Generations Of The Dead* (Young Vic), *Twelfth Night* (London Bubble), and *Curious Incident Of The Dog In The Night-time* (NT UK Tour).

TV includes: *Damned, Shoot The Messenger, Family Affairs, Eastenders, Holby City,The Riots, Men Behaving Badly, Death In Paradise, Clapham Common, Talk To Me, Big Women, Babyfather, Casualty, The Bill, All in The Game*, and *Pigheart Boy* (BAFTA best children's drama).

Film includes: *Ladybird, Ladybird, Secrets and Lies, Whole New Heart, Bullet Boy (Screen Nation Best Actress), Hallelujah Anyway, 7Lives*, and *Blacklands*.

Radio includes: *Westway, Brassic, Weak At The Top, Number 10, A Little Princess, Corrine Come and Gone, Landfall, Stardust, The Forsytes, Miss You Still, Charles Paris, Blood and Milk, Carnival, Stars, lifelines, Comment Is Free, Ragamuffin, The Winter House*, and *The Clintons*.

Clare is a mother and grandmother and is Patron of Brixton Inclusive.

## SEAN JACKSON
**Peter**

Theatre includes: *Macbeth* (Shrewsbury), *The Hook* (Northampton/ Liverpool Everyman), *Antony & Cleopatra*, *Holy Warriors* (Shakespeare's Globe), *Richard III* (Nottingham Playhouse/York Theatre Royal), *Say It With Flowers* (Hampstead), *Beauty and the Beast*, *Waves* (New York), *The Seagull*, *A Dream Play*, *The Mandate*, *Iphigenia at Aulis*, *The Talking Cure*, *Ivanov* (National Theatre), *Richard II*, *Hamlet* (Broadway), *The Wild Duck* (Donmar Warehouse), *The Jewish Wife* (Young Vic), and *Henry V* (Manchester Royal Exchange).

TV and film includes *The Innocents*, *Eddie the Eagle*, *Da Vinci's Demons (2 series)*, *The Fear*, *Silent Witness*, *Waking the Dead*, *Eastenders*, and *No Man's Land.*

Audio includes *Dalek Empire 3 – The Exterminators* and *Doctor Who – The Marian Conspiracy* (Big Finish).

## GUY RHYS
**Septimus**

Theatre includes: *Not now*, *Bernard* (Unicorn Theatre), *The Resistible Rise of Arturo Ui* (Donmar Warehouse), *St Joan* (Donmar Warehouse), *Jason and the Argonauts* (Unicorn Theatre), *Bird* (Sherman Cymru/Royal Exchange), *Pomona* (Orange Tree/National Theatre/Royal Exchange), *My father*, *Odysseus* (Unicorn Theatre), *Wendy & Peter Pan* (RSC), *Star Cross'd* (Oldham Coliseum), *A view from the Bridge* (Royal Exchange), *Rafta Rafta* (Bolton Octagon/ New Vic Theatre), *Mother Courage and her Children* (National Theatre), *The Allotment* (New Perspectives), *A Streetcar Named Desire* (Theatr Clywd), *Murmuring Judges* (Birmingham Rep), *The Powerbook* (National Theatre), *Othello* (Nottingham Playhouse), *Hijra* (West Yorkshire Playhouse), *Transmissions* (Birmingham Rep), *Romeo & Juliet* (Chichester Festival Theatre), and *The Ramayana* (Birmingham Rep/National Theatre).

Television includes: *Motherfatherson*, *The Crimson Field*, *Emmerdale*, *Fallout*, *Sorted*, *Doctors*, *Holby City*, *No Angels*, *The Last Detective*,

*Outlaws, Fat Friends, Dalziel & Pascoe, A&E, Big Bad World II*, and *The Bill*.

Radio includes: *Emile Zola: Sex, Blood and Money* (BBC).

Film includes: *Mary, Queen of Scots* (Working Title/Universal), *The Festival* (Film4), and *How to build a Girl* (Film4).

## CLARE LAWRENCE MOODY
### Sally

Theatre includes: *The Divide* (Edinburgh Festival/Old Vic), *Punts* (Theatre503), *Home Chat* (Finborough), *Mill Hill* (St James'), *The Distance* (Orange Tree), *A Door Should be Open or Shut* (Chichester), *Shelley* (West Yorkshire Playhouse/Oxford Playhouse), *Age of Arousal* (Royal Lyceum), *The Girls of Slender Means* (Edinburgh Festival), *Mine* (Shared Experience/Hampstead Theatre/Tour), and Fram (National Theatre).

Film includes: *Pride* and *This Could Be The Last Time.*

Television includes: *Gentleman Jack, Agatha Raisin, EastEnders, Doctors, Holby City, Ultimate Force, Bad Girls, The Bill, Longitude.*

Radio includes: *The Norman Conquests, Democracy for Beginners, The Ambassadors, A Domestic, Let's Murder Vivaldi*, and *Amerika, 27 Wagons Full of Cotton*, all for BBC Radio 4.

Clare's producing credits include: *This Is Our Youth* (Garrick Theatre), *Life In The Theatre, Fool For Love* (Apollo Theatre), *Oleanna* (Garrick Theatre), *Some Girls* (Gielgud Theatre), and *Five Kinds of Silence* (Lyric Hammersmith).

**arcola**
theatre

# Arcola Theatre is one of London's leading off-West End theatres.

Locally engaged and internationally minded, we stage a diverse programme of plays, operas and musicals. New productions from major artists appear alongside cutting-edge work from the most exciting emerging companies.

Every year, our Participation department creates over 13,500 creative opportunities for the people of Hackney and beyond, and 26 weeks of free rehearsal space for theatre artists of colour. Our pioneering environmental initiatives are internationally renowned, and aim to make Arcola the world's first carbon-neutral theatre.

www.arcolatheatre.com
020 7503 1646

## MAKE THIS HAPPEN

Become an Arcola Supporter from just £4.17 a month
**www.arcolatheatre.com/support**

Or make a one-off donation now
Text **ARCO14** and **£3**, **£5** or **£10** to 70070

# MRS DALLOWAY

# MRS DALLOWAY

by Virginia Woolf
adapted by Hal Coase

OBERON BOOKS
LONDON

WWW.OBERONBOOKS.COM

First published in 2018 by Oberon Books Ltd
521 Caledonian Road, London N7 9RH
Tel: +44 (0) 20 7607 3637 / Fax: +44 (0) 20 7607 3629
e-mail: info@oberonbooks.com
www.oberonbooks.com

PB ISBN: 9781786826404
E ISBN: 9781786826411

Cover design by Emma D'Arcy

Printed and bound by 4EDGE Limited, Hockley, Essex, UK.
eBook conversion by Lapiz Digital Services, India.

10 9 8 7 6 5 4 3 2 1

NOTES:

There are over twenty characters named in the text, as well as many other unnamed perspectives. The play as published here was performed by five actors; other cast sizes are possible.

Character names placed in *italics* indicate the line expresses an unvoiced thought, mood or reaction. This does not always mean that an actor playing the role of that character should deliver the italicised line, only that in performance the connection of the line to their character should be clear.

Where lines need not be directly connected to a particular character they are marked with a dash.

The prologue published here (running from the actors first entrance to Clarissa's entrance) was written for five actors. It may be adapted for other casts. Ideally, all actors should be seen and heard in the prologue with the exception of the actor playing Clarissa. In any event, it can be altered provided it adheres to the structure and tone laid out here: a casual introduction to the actors and the novel; an acknowledgement of the place where the performance is happening; followed by a discussion about 'this feeling of not knowing people and not being known'. It must include all of the text directly quoted from Woolf. It should be disarming, honest and unstudied. It must make explicit Woolf's interest in and delicate critique of 'judging' character – both in fiction and in life.

Pauses and beats are indicated by a blank line on the page; the length of a pause is suggested by the length of this blank space.

There is no interval.

*Actors **1** and **2** enter the space:*

| | |
|---|---|
| **1** | Hi everyone! |
| **2** | Hello. Thanks for coming to the show. |
| **1** | Yes – thank you. |
| **2** | We'll be starting soon after a bit of a preamble. |
| **1** | Before all that ambling! |

My name's [first name]. I'm an actor, obviously! I live in [place]. I've lived there for [how long]. And I think the thing I love most about living in [place] is [personal reason].

And I first read *Mrs Dalloway* when I was a teenager.

**2** And my name's [full name]. And I live in Westminster. No, only joking! Imagine! No, I live in [place]. And the thing I love most about living in [place] is the people. Yeah, the people are great.

I first read *Mrs Dalloway* about a month ago when I got this part because I thought that might be helpful.

**1** Great. OK, great. Who else here lives in London?

*Audience responds.*

Well, that makes sense! That's good. The book's about London – and lots of other things.

**2** Lots of other things!

**1** Yes.

**2** Right now we want to mention and reflect on the idea that when 'so much strength is spent on

finding a way of telling the truth, the truth itself is bound to reach us in rather an exhausted and chaotic condition.'

That's Virginia Woolf in her essay 'Mr Bennett and Mrs Brown', which was published in 1924, the year before *Mrs Dalloway*.

'An exhausted and chaotic condition' – maybe that's the best we can hope for.

| 1 | That's also one hell of a disclaimer, isn't it? 'Hey! Fuck ups are inevitable! We're doing our best!' |
|---|---|
| 2 | I like it. |
| 1 | I know. Me too. Do you want to say anything else about it? |
| 2 | Not right now. When we're all ready, we're going to start with her – Mrs Dalloway. |

How is everyone feeling?

*Audience responds.*

| 1 | Well I feel terrified! |
|---|---|
| 2 | Do you? |
| 1 | Yes. |
| 2 | Are you – *terrified?* |
| 1 | Yes! |
| 2 | Why? |
| 1 | I couldn't say. How are you doing? |
| 2 | I'm excited. |

| | |
|---|---|
| 1 | Really? |
| 2 | Yeah, always excited. Ecstatic, even! |
| 1 | Ecstatic? |
| 2 | Absolutely. |
| 1 | Right. OK. |

*3 and 4 enter – 3 is carrying flowers.*

| | | | |
|---|---|---|---|
| 3 | Hi everyone. | | |
| 1 | Hello. | 2 | Hi. |
| 4 | She's just coming. | | |
| 2 | This is – | | |
| 3 | I'm [first name]. | | |
| 2 | [second name]. | | |
| 3 | Yeah, [full name]. Thanks. | | |
| 4 | I'm [full name]. Hi. | | |
| 2 | Good of you to show up. | | |
| 3 | S/he says that every night. | | |
| 2 | I do, yes. It's funny. What are those? | | |
| 3 | [name of flowers]. | | |
| 2 | They're beautiful. | | |
| 4 | Ready? | | |
| 2 | Yes. Shall I do her entrance? | | |
| 4 | Sure. | | |

| | |
|---|---|
| 3 | Are you excited? |
| 2 | I am, yes. Are you? |
| 3 | Yup and [1] is / terrified? |
| 2 | Terrified – but s/he can't say why! |
| 3 | But what does the brain matter, compared with the heart? |
| 2 | Said Lady Rosseter, getting up. |
| 1 | I will come. |
| 4 | Said Peter Walsh, but he sat on for a moment. |
| | *2 exits.* |
| 1 | What is this terror? |
| 4 | What is this ecstasy? |
| 2 | He thought to himself. |
| 1 | What is it that fills me with extraordinary excitement? |
| 4 | It is Clarissa. |
| 1 | He said. |
| 3 | For there she was. |
| 4 | For here she is… |

*2 enters as 'Mrs Dalloway'.*

| | |
|---|---|
| 2 | *?* |
| | |
| 1 | No. |
| 2 | No? |
| 1 | Yes, no, sorry – it's – |
| | Unsatisfactory. |
| 2 | Unsatisfactory? |
| 4 | Well she's more… It's more sort of – pinched? I think is what s/he means. |
| 3 | Pinched?          2          Pinched? |
| 1 | No, I don't think – 'pinched' – ? |
| 4 | Poised, then – it's more *poised.* |
| 2 | She comes into a room, this room – any room – a room – she comes in – kind, curious, sentimental – she stands, like this, she stands, like we've always seen her stand – in a well-lit doorway with us gathered round her – and there she is. |
| 1 | But can we talk about – … I want to try and explain this feeling of dissatisfaction? |
| 3 | With what? |
| 1 | 'It is Clarissa. He said. For there she was.' |
| 2 | Here she is. |
| 1 | No, no, I know but people – generally – *in general,* can we talk about that again? I mean – |

5

not knowing people, what is that feeling? Of not knowing people and not being known.

4    Yes. Yes – like, the usual example, OK? Take us – we might meet every day, rehearsing, then come here, every night maybe, most nights, and then one day we won't meet. And then we won't meet for a week, for weeks, for six months, a year – years! YEARS! And it is – it *is* unsatisfactory – that's true. There's never…enough, is there?

2    Enough…?

4    Of someone… To just – make a judgement? A decision – or?

3    Everyone in this room is a judge of character. It's not difficult.

4    Yes, OK, but you can't say, 'I am this or I am that' –

3    Yes – you can.    2    Why not?

4    For the same reason s/he can't say, 'You are this or you are that' –

3    Is it just too hard to say what you mean?

4    I don't know what I mean.

1    Of course you don't – in the last week you've had experiences you couldn't begin to describe.

4    Yes.

1    In one day thousands of ideas have run through your brain –

4    Right.

6

| | |
|---|---|
| 1 | Thousands of emotions have collided and disappeared in chaos – |
| 3 | Woah, woah, woah – let's take a second. OK? |
| 4 | Here we are, once again, starting again – trying to explain Clarissa. |
| 2 | Clarissa Dalloway. |
| 3 | Mrs Dalloway. Yes? |
| 1 | Yes.                    4          Yes, fine. |
| 3 | She is kind, curious, and sentimental. |
| 2 | She embroiders, she knits, she holds parties – |
| 3 | She spends four nights a week at home with her daughter, Elizabeth – |
| 2 | Who looks nothing like her. |
| 3 | She has a beaklike nose. |
| 2 | She sleeps badly. |
| 3 | She eats well. |
| 2 | She has a sickly constitution. |
| 3 | She is currently reading Baron Marbot's *Memoirs.* |
| 2 | Without knowing precisely what makes the evenings disagreeable – |
| 3 | But with a sense that they are, indeed, disagreeable – |
| 2 | She goes to bed each evening with a slight pressure on the top of her head – |

| | |
|---|---|
| 3 | Just here. |
| 2 | Just here. |
| 3 | There is nothing picturesque about her, nothing beautiful. |
| 2 | She never says anything especially clever. |
| 3 | But there she is, nonetheless. These are the facts. |
| 2 | There are many more. |
| 3 | And without them we lose all sense of proportion – |
| 2 | And we're left with failures and fragments – |
| 1 | Then we'll have to make do with failures and fragments. |
| 3 | You've given up. |
| 1 | No. |
| 2 | Good, because we need her here? Right? |
| 1 | Right – but she feels herself everywhere. |
| 3 | I never know what that means. |
| 4 | In the ebb and flow of things somehow, in the streets of London, here, there, here, there, here – she has lost herself in the process of living – so that to know her – |
| 1 | Or anyone – |
| 4 | Yes, or *anyone* – to know her – or anyone – you must seek out the people who completed her. |

| | |
|---|---|
| 1 | And the places – even the places that completed her. These odd connections – affinities she has with people she has never spoken to – some woman in the street – |
| 4 | Some man behind a counter – |
| 1 | Even trees – |
| 3 | The trees…          **4**          Yes. |
| 1 | Or rivers. |
| 4 | Yes. |
| 1 | Or skies. |

| | |
|---|---|
| 3 | Maybe you should call me when she's here. |
| | *3 exits.* |
| 2 | OK. She's everywhere and that's fine. But she comes in, she comes in *somewhere* right now – one time – like this – just once. |
| | I will – *she* will be right back. |
| | *2 exits.* |

| | |
|---|---|
| 4 | Skies…? |
| 1 | Yes! |
| | I always have this feeling that it is very, very dangerous to live even one day. |

| | |
|---|---|
| **4** | It is, yes. It is. |
| | But fear no more, says the heart in the body. |
| **1** | Committing its burdens to some sea, which sighs collectively for all sorrows. |
| **4** | And I can't say of myself now: I am this, I am that. Now or ever – |
| **1** | But I renew. |
| **4** | I begin. |
| **1** | I collect. |
| **4** | And I let fall. |
| **1** | I feel very young. |
| **4** | At the same time I feel unspeakably aged. |
| **1** | Begin. |
| **4** | Renew. |
| **1** | Collect. |
| **4** | Let fall. I cut like a knife through everything. |
| **1** | I am, at the same time, outside – looking on. |
| **4** | What I love is – |
| | *5 enters as 'Mrs Dalloway'.* |
| **1** | Yes? |
| **4** | This, here, in front of me. |

| | |
|---|---|
| **Clarissa** | I will buy the flowers myself. |
| – | Mrs Dalloway said she would buy the flowers herself. |
| – | And went out into this moment in June, 1923. |
| – | Westminster, London. |
| *Clarissa* | And she's thinking... WHAT A MORNING! Fresh as if given to children on a beach – the whole world for a moment perfectly silent. You step out of your home – you stand under the steadfast summer sky, and stupid as this may sound, it holds, this sky, something of you in it. Yes! For I have lived here in Westminster for over twenty years, and I know that this sky holds something of me in it, so I can feel always, even in the midst of traffic, a silence in the air before Big Ben strikes. Today only the sound of that aeroplane coming over the trees of St James's is new – and there is still, as always, this pause, this suspense... And then – |

*She waits.*

*Big Ben strikes 10. The leaden circles dissolve in the air.*

| | |
|---|---|
| – | June has drawn out every leaf on the tree – |
| – | Arlington Street and Piccadilly seem to scrape the very air in the parks and lift their leaves brilliantly in wave upon wave of heat. |
| **Clarissa** | Tonight I will be part of it all – |
| – | She will stand at the top of the stairs – her hands full of flowers – |

-        A radiancy, no doubt, in some dull lives –

-        SHE WILL GIVE HER PARTY.

*Clarissa* begins her walk through London – *others pass her:*

-        There she goes – that charming woman – poised,
         eager, strangely white-haired for her pink cheeks –

-        Or so Mr Purvis thought her as he hurried to his
         office. And there she goes – Mrs Dalloway, with
         her ridiculous little face: old, beaked like a bird's
         – but she holds herself well –

-        So Mrs Asquith thought her as she stood for a
         moment at St James's gates. There is indeed a
         touch of the bird about her – of the jay, blue-
         green, light, vivacious –

-        So Mrs Foxcroft thought as she watched Mrs
         Dalloway crossing Victoria Street. Here, now it
         is the height of summer – and the War, the Great
         War, is over –

-        Except for me, Mrs Foxcroft, who, at the Embassy
         last night, ate my own heart out clutching a
         telegram because John, my favourite, was killed
         and now it is decided that the old house must go
         to a cousin –

-        But it is over. / The War is over.

-        Thank God. The War is over.

-        And here it is the height of summer – waves of
         heat collect, / overbalance and fall –

-        Collect and fall, and the whole world says, 'That is
         all', / until even the heart –

| | |
|---|---|
| – | Until even the heart in the body lying in the sun says too, 'That is all' – |

*Clarissa walks into St James's park:*

| | |
|---|---|
| *Clarissa* | That is all it takes – I walk into St James's park – to see the trees and the grass, that girl in pink and the sky – they all bring it back to me: my childhood in the old house at Bourton, and that summer – thirty years ago – with Sally and Peter sitting round after tea on the terrace, bathed in yellow light – |
| **Peter** | Let's talk a while longer. |
| – | That was Peter Walsh – |
| *Peter* | It is my talking you remember. |
| *Clarissa* | He is back from India one of these days, June or July, I forget which, for his letters are incredibly dull. |
| **Sally** | Let's go down to the lake! |
| – | That was Sally Seton – |
| *Sally* | It is my laughter you remember. |
| **Clarissa** | Oh but everyone remembers! What I love is this, here, now, spilling out – |
| – | In these people's eyes, in the swing, tramp, and trudge; in the bellow and the uproar; beyond the park the carriages, motorcars, omnibuses, vans, sandwich men shuffling and swinging; brass bands; barrel organs; in the triumph and jingle and the strange high singing of some aeroplane above is what she loves: life, London, this moment in June. |

13

***Hugh** approaches her.*

| | |
|---|---|
| **Hugh** | Good morning to you, Clarissa! |
| **Clarissa** | Hugh – good morning! |
| – | How fat he is getting! |
| **Hugh** | And where are you off to? |
| **Clarissa** | Nowhere in particular – |
| – | Yes, the flowers for your party. |
| **Clarissa** | You know I love walking in the parks. |
| – | Why must she always feel insufficient beside Hugh Whitbread? |
| **Clarissa** | Are you up in town long? |
| – | Insufficient and yet so…attached – |
| **Hugh** | We have just come up – to see doctors, unfortunately. |
| – | Attached, yes, partly from having known him since her childhood at Bourton – |
| **Clarissa** | Is Evelyn ill again? |
| – | Partly because of his kindness. |
| **Hugh** | Yes, she's a good deal out of sorts, I'm afraid. |
| – | Partly because of how Sally and Peter had loathed him, and she defended him. |
| **Clarissa** | What a nuisance. |
| **Hugh** | Yes, terrible. |

14

| – | Not the right hat for the early morning, is that it? |

**Hugh**     But you will see us at your party tonight – Evelyn absolutely insists.

**Clarissa**     Wonderful.

*Peter and Sally return.*

**Hugh**     I may be late – I'll be coming from the Palace.

**Clarissa**     I shall see you later then.

**Hugh**     Until then!

**Clarissa**     Goodbye Hugh.

*A memory – thirty years ago at Bourton:*

**Sally**     Do let us know when you've had an original thought!

**Clarissa**     Sally!

**Sally**     I don't care!

**Peter**     Is he gone? Tell me he's gone?

**Sally**     He's gone, Peter.

**Peter**     Thank God.

**Sally**     Gone to bother the kitchen girls. Why do you invite him to Bourton?

**Clarissa**     Why must you make such a scene?

**Peter**     Why must he talk like he's a fifty-year-old Tory?

**Sally**     Because one day he will be! *(Imitating **Hugh**.)* Ah yes, Women's Rights, that old chestnut!' Christ!

| | |
|---|---|
| *Clarissa* | You should leave him be – |
| **Sally** | The moment he leaves *me* be – |
| *Clarissa* | What is the matter with you two tonight? |
| **Sally** | Nothing but an adverse reaction to spending the whole evening with a first-rate prick. |
| *Clarissa* | Sally – |
| **Sally** | Prig. |
| *Clarissa* | Hugh is perfectly tolerable. |
| **Peter** | And you have the makings of a perfect hostess. |
| **Sally** | The boy has no heart – no brain! |
| **Peter** | Precisely. Has read nothing – |
| **Sally** | Felt nothing – |
| **Peter** | Thought nothing – |
| **Sally** | Has nothing but the manners and 'breeding' of a gentleman – |
| *Clarissa* | But he is kind, which ought to count for something. And quite unselfish – |
| **Sally** | Unselfish? He thinks of nothing but his own appearance. |
| *Clarissa* | And is there such harm in that for a young man? |
| **Sally** | Yes! Yes – absolutely – he'll do more harm with that than you can imagine – such a sense of 'order' is lethal. |
| **Peter** | No country but England could tolerate him – |

| | |
|---|---|
| *Sally* | No country but England could have produced him. |
| | He kissed me in the smoking-room. |
| *Clarissa* | He *what?* |
| *Sally* | Grabbed me and kissed me. |
| *Clarissa* | He wouldn't – |
| *Sally* | He would and he did. |
| | |
| *Peter* | Sally – I'm most awfully sorry. |
| *Sally* | Forget it. |
| | |
| – | Some sights bring Bourton back to her calmly – |
| **Sally** | Forget it. |
| – | Others strike her suddenly – |
| *Sally* | Oh it's a damn shame to sit indoors – let's go down to the lake. |
| *Peter* | It's almost dark. |
| *Sally* | Full moon tonight, the sky's cleared, we'll see the lilies at their best. |
| | Come on! |
| | *Peter* and *Sally* move off. |
| – | If Peter were here now, for instance, if he had seen her talking to Hugh – what would he say? |
| – | 'The perfect hostess!' |

*Peter returns.*

| | |
|---|---|
| *Peter* | Clarissa? |
| *Clarissa* | Yes – yes, I'll follow you. |
| **Sally** | *(Off.)* Hurry up! |
| – | Or take Sally's way with flowers, for instance – at Bourton Sally went out, picked all sorts of flowers that had never been seen together, cut their heads off and made them swim on the top of water in bowls. |
| **Clarissa** | The effect was extraordinary – coming in to dinner in the sunset – |
| – | She could never forget Sally's way with flowers. |
| – | That is all. |
| – | Fear no more, says the heart in the body. |

*The memory goes. A florists:*

| | |
|---|---|
| **Miss Pym** | Good morning Mrs Dalloway. |
| **Clarissa** | Good morning Miss Pym – some flowers for my party this evening. |
| **Miss Pym** | Very good. May I suggest delphiniums? |
| **Clarissa** | Whatever you think best. |
| – | Fear no more the heat of the sun. |
| **Clarissa** | Some sights bring them back to me calmly, without the old bitterness – which perhaps is the reward of having cared for people, despite Peter's demands, his scenes, his revelations, his running away to India – his absence, for years now – |

| | |
|---|---|
| – | But still, still – they might be parted for hundreds of years – she, Peter and Sally – suddenly they would come to her. Without them she had the oddest sense… |
| **Clarissa** | Of being myself invisible…unseen, unknown, unknowable… |
| – | Which perhaps is the reward of having cared for people. |
| – | This being Mrs Dalloway. Not even Clarissa any more. This being Mrs Richard Dalloway, the perfect hostess. |
| *Clarissa* | Now – it is true that half the time I do things not simply for themselves – but to make people think this or that – perfect idiocy I know, for no one is ever for a second taken in – |
| **Miss Pym** | What do you think? Delphiniums and carnations. |
| **Clarissa** | Perfect. They're perfect. |
| – | That is all. |
| | *An explosion outside.* |
| – | THE WORLD HAS RAISED ITS WHIP – |
| **Miss Pym** | Dear me, those motorcars! |
| – | Where will it descend? |
| **Miss Pym** | *(Looking out.)* Oh but they do look important! |
| – | Who is it? |
| **Clarissa** | Who is it? |
| – | Who is it? |

*On the street:*

–  The car: drawn to the side of the pavement – low
and grey –

–  Inside the car: a face of the very greatest
importance against the dove-grey upholstery –

–  The Prince of Wales?

–  The Prime Minister?

–  The Queen?

–  The car moves on.

–  The Prince of Wales?

–  The Prime Minister?

–  The Queen?

–  A face only seen once by three people for / a few
seconds.

–  A few seconds – but a face of the very greatest
importance.

–  The car comes on.

–  Greatness is passing down Bond Street.

–  The Queen going to some hospital.

–  The Queen opening some bazaar.

–  Was it the Prince of Wales's, the Queen's, the
Prime Minister's?

–  The car comes on.

| | |
|---|---|
| – | Was it the Queen in there – the Queen going shopping? |
| – | Whose face was it? |
| – | Who is it? Who is it? Who is it? Who is it? Who is it? Who is it? Who is it? WHO IS IT? |
| *Septimus* | Mystery – see how she has brushed us with her wing. That face in the motorcar will not be known until curious archaeologists, sifting the ruins of time, when London is a grass-grown path, and the land reverts to its ancient shape, and the hills have no names, and all of us here are but bones with a few wedding rings mixed up in their dust – the face in the motorcar will then be known. I know. I have heard the voice of authority. Evans is here. He has a message – a supreme secret. And the spirit of religion is abroad, with her eyes bandaged tight and her lips gaping so wide. Everyone is drawing together – everything comes to one centre before my eyes – but I am in the way. It is I who am blocking the way – no – for what purpose? Must they stare and look and point at me – I will burst into flames – I will, I will, I will – |
| **Rezia** | Septimus Warren Smith. |
| *Septimus* | I will not go mad. |
| **Rezia** | SEPTIMUS? |
| **Septimus** | But I have committed a most appalling crime. I feel nothing. And I have been condemned to death by human nature. |
| – | 'There is a very remarkable inclination in human nature to bestow on external objects the same |

21

emotions which it observes in itself and to find
everywhere those ideas most present to it.'

–       David Hume, philosopher, *A Treatise of Human
        Nature*, Volume 1, 1738.

–       'Human nature is the same now as when Adam
        hid from the presence of God; the consciousness
        of wrong makes us unwilling to meet those whom
        we have offended.

–       Matthew Simpson, priest, Sermons, 1885.

–       'Se fosse tutto        –       'If all my
        pieno il mio                    prayers were
        dimando,'                       answered,' I
        rispuos' io lui,                said to him,
        'voi non sareste                'you would not
        ancora de                       yet be banished
        l'umana natura                  from human
        posto in bando.'                nature.'

–       Dante Alighieri, poet, Inferno, Canto 15.

–       'What can you say? It's only human nature – you
        go through certain things alone.'

–       Mary Warren Smith, mother, living room, 11th
        February 1919.

**Septimus**   I survived the Great War and then I drowned in
               Human Nature.

**Rezia**      People are looking, Septimus – please – let us go on.

**Septimus**   They are looking – yes. I'm sorry.

**Rezia**      Thank you. Look – see – how bright the trees are
               today. It is a very lovely morning for England.

| | |
|---|---|
| *Septimus* | But here, even here – the spirit of religion – at Hyde Park Corner on a bucket she stands preaching Proportion – |
| **Rezia** | And see those people on the omnibus. How beautiful they are! |
| *Septimus* | She stands disguised as brotherly love walking through parliaments, offering help but desiring power – |
| **Rezia** | Your arm, Septimus. |
| *Septimus* | She will set Human Nature on you and then she will convert you to silence. |
| **Rezia** | Septimus? Look – we will cross over to the park. Give me your arm. |
| – | Septimus! Your wife has a right to your arm, though it's without feeling. She who is simple, impulsive, twenty-four, who left Italy for your sake, five years ago, who is without a friend in all England, she has a right to a piece of bone. |
| **Rezia** | Your arm, please. |
| **Septimus** | Yes, of course. |
| **Rezia** | Thank you. |
| *Septimus* | My piece of bone – |
| **Rezia** | Look – we will go over to that bench there, it is a lovely spot. |
| **Septimus** | A piece of bone – in the rough stream of a glacier the ice holds a piece of bone, a blue petal, and rolls it on, year in year out, crushing and converting whatever it might be: this vow, this life, this hope – |

| | |
|---|---|
| – | And just now that low, grey motorcar swept past Marble Arch and nobody noticed it. |
| **Rezia** | Look – we will sit here – |
| **Septimus** | I will sit here. |
| **Rezia** | Yes. Look – we will sit together. And then in one hour we will be going to this Sir Bradshaw – |
| **Septimus** | First Holmes and now Bradshaw. |
| **Rezia** | Sir Bradshaw is the very best in London. He will help us. |
| | Oh now look at that – Septimus, an aeroplane! |
| – | Dr Holmes has told her to make him notice real things. |
| **Rezia** | Oh! It is writing something! K... R... Can you see? Septimus? K... R... |
| – | Yes. The aeroplane! In its drone the voice of the summer sky murmurs its fierce soul. |
| – | Haven't we always dreamed of flight? And now some fine young feller is making our dream his own. Away and away, fast and fading, till it is nothing but a bright spark, an aspiration, a symbol of something which has soared beyond seeking and has become all spirit – |
| – | So it seems to Mr Bentley, vigorously rolling his strip of turf at Greenwich – |
| – | All spirit and a symbol of man's soul, a symbol of speculation, a symbol of man's determination to get outside his body by means of thought, by pure |

24

mathematics, and now sped of its own free will –
it WRITES!

|   |   |
|---|---|
| – | Um… K… R… |
| – | Kruh…? |
| – | No, uh, Kree…? |
| – | No, no, no, no… K… T… |
| – | That's a T? |
| – | No – wait, is it? |
| – | No. G! |
| – | That's Kree… Kreemo? |
| – | G. L. See? G. L. Gl… Gl… Gl… |
| – | No, look. K… R… |
| – | K. R. |
| – | Kay. Arr. |
| – | KAY. ARR. |
| **Septimus** | So – they are beckoning – they are calling. |
| – | KAY… ARR… |
| *Septimus* | It begins. |
| **Rezia** | Look, look, Septimus – they are advertising something. K… No, no. T… T. O… You see? Septimus? Look. |
| *Septimus* | It is him. He is signalling to me. |

| | |
|---|---|
| **Rezia** | T… O… |
| – | TEE. OOH. |
| **Septimus** | He is signalling. Not indeed in actual words – that is, I cannot read the language yet, but it is plain enough, he is beckoning. Yet one must be scientific, above all scientific – the aeroplane, the child crying, the motorcars, the trees, the horns, the sparrows, the whistling, and the spaces between the sounds as significant as the sound… All together mean the birth of a new religion – |
| **Rezia** | Septimus! I am going to walk to the fountain and back. |

*Rezia leaves him.*

| | |
|---|---|
| **Septimus** | So the rope is cut. |

You are alone. She cannot help you.

And now you must make it known – men must not cut down trees, there is a God, change the world, no one kills from hatred, / the birth of a new religion –

*Holmes appears.*

| | |
|---|---|
| **Holmes** | Now what's all this about? |
| **Septimus** | The thumbscrew has arrived. |
| **Holmes** | Talking all this nonsense to frighten your wife? |

26

| | |
|---|---|
| *Septimus* | Look – once you stumble – human nature is on you – Dr Holmes is on you – |
| *Holmes* | And you do not answer to human nature? |
| *Septimus* | No, I do not. I have – … I / have – |
| *Holmes* | Have you considered taking up a hobby, Mr Warren Smith? Throwing yourself into outside interests? |
| *Septimus* | I have committed an appalling crime and I have been condemned to death by human nature. |
| *Holmes* | I can see you are in a funk. |
| *Septimus* | Once you fall, Holmes is on you. The rack and thumbscrew are applied. They will convert you to 'reason' – |
| *Holmes* | Here's a little something to help you sleep – |
| *Septimus* | Human nature is remorseless – human nature is – |
| **Rezia** | Septimus? It is me, my love. |
| | *Septimus takes her hand and stares at it – her ring is missing.* |
| **Rezia** | Oh – my hand has grown so thin. I took it off and put it in my purse. |
| *Septimus* | Go alone. Go now. The supreme secret must be carried to the Cabinet – |
| **Rezia** | You are talking to yourself again. |
| **Septimus** | To the Prime Minister – |
| – | MAKE IT KNOWN – |

| | |
|---|---|
| **Rezia** | No, Septimus, please. It is just me. You see? |
| **Septimus** | Yes. |
| **Rezia** | Yes? We are going to sit together here – |
| **Septimus** | Yes. |
| **Rezia** | And soon we will go to get you the help you need. |
| **Septimus** | Thank you. |
| **Rezia** | That's better. Oh – but you must be so very hot. Here. |

*She slips his overcoat off his shoulders, leans against him.*

| | |
|---|---|
| *Septimus* | No – God – no – white things – beyond those railings. |
| **Rezia** | Yes, you see – the aeroplane? Is it not so pretty? |
| **Septimus** | Evans. |
| **Rezia** | No. No, love, he is not here. Look – |
| *Septimus* | Signalling to me. Taken from life to death and back again – EVANS! |
| **Rezia** | Listen. Build it up – first one thing, then another – |
| *Septimus* | Evans behind those railings. |
| **Septimus** | We must get away from people, right away over there – |
| **Rezia** | No, Septimus, please – |

| | |
|---|---|
| *Evans* | SEPTIMUS – STOP – LISTEN – remember, my friend, how we were together in France, in Italy, how we fought, how we played, how we quarrelled, and how we loved. |
| **Septimus** | Yes – yes, I remember – |
| **Rezia** | That's it – remember what Dr Holmes said. |
| *Evans* | And how you felt nothing for my death – |
| *Septimus* | No. I couldn't. |
| **Rezia** | But you must stay calm. |
| **Septimus** | I can't. |
| **Rezia** | You must. |
| **Septimus** | Evans? |
| **Rezia** | No! Stay here – with me, please. |
| **Septimus** | Please. Please – what must I do? |
| *Evans* | You must learn the meaning. And make it known to the mass of men: no crime, love, universal, boundless love, heaven is divinely merciful, chaotic, infinitely benign – it will pardon you, it will release you – |
| **Rezia** | Stop this. Look – look at me – Septimus. |
| *Evans* | It has released me. I have been dead and yet am now alive and I am with you. |
| **Rezia** | Septimus! |
| *Evans* | The flesh has melted off the world and yet I am with you – we welcome, we accept, we release, we create – |

| | |
|---|---|
| **Maisie** | Excuse me – Regent's Park tube? Could you tell me the way to Regent Park's tube station? |
| **Rezia** | Over there – over there! |
| **Maisie** | Goodness me! Both seem very queer... Everything seems very queer. |
| – | Maisie Johnson, who turned seventeen just yesterday, in London for the first time, come to take up a post at her uncle's in Leadenhall Street, and now walking through Regent's Park in the morning, thought this couple on the chairs seemed foreign and queer. |
| **Maisie** | So that now I am very old I still remember them and make them jangle among my memories – how I walked through Regent's Park on a fine summer's morning fifty years ago and had asked the way of this couple and the girl started and jerked her hand, and the man – he seemed awfully odd; quarrelling, perhaps, parting forever, perhaps... |
| – | Why hadn't she stayed at home? |
| **Maisie** | Ah, but that aeroplane! Away and away and away. |
| – | It swept and fell. Swept and fell. Down and up again. |
| – | And the writing... F... F... E... E...was it? Yes... |
| **Maisie** | Toffee... It's toffee! |

*Up to the sky and back down to **Clarissa** – returning home with flowers:*

| | |
|---|---|
| **Clarissa** | What are you looking at? |

| | |
|---|---|
| **Lucy** | The aeroplane, ma'am. |
| **Clarissa** | Oh yes – look at that. Gosh, what *is* it doing? |
| **Lucy** | Some advertisement or something – |
| **Clarissa** | An advertisement! What a world this is. |
| | *They go inside:* |
| **Lucy** | Let me take those. |
| **Clarissa** | Thank you. That is better. Any messages? |
| **Lucy** | Yes, one – Lady Millicent Bruton wished to know if Mr Dalloway would lunch with her. |
| **Clarissa** | He's in committees all day – |
| **Lucy** | He's just come back to change for lunch – |
| **Clarissa** | Oh, I see. Thank you, Lucy. Nothing for me? |
| **Lucy** | No. |
| **Clarissa** | Thank you. Now, how is Mrs Walker getting on in the kitchen? |
| **Lucy** | Very well. |
| **Clarissa** | Good! Thank you. And the silver does look nice. |
| | If you'll excuse me, I must mend my dress. |
| **Lucy** | Of course. |
| **Clarissa** | That cushion there is hideous – take it to Mrs Walker with my compliments. Then we are almost there. Thank you. |

*Lucy goes out. **Richard** enters, holding some flowers.*

| | |
|---|---|
| **Richard** | For you. |
| **Clarissa** | Richard – how lovely! |
| **Richard** | What have they been doing in here? It all looks so empty – |
| **Clarissa** | For the party – |
| **Richard** | Oh yes, the party. |
| **Clarissa** | Had you – |
| **Richard** | No, no, I hadn't forgotten. In fact, the Prime Minister might be coming. And I shall ask Lady Bruton at lunch. |
| **Clarissa** | Just the two of you? |
| **Richard** | And Hugh. |
| **Clarissa** | I saw him this morning. |
| **Richard** | He's getting absolutely intolerable. |
| **Clarissa** | Yes. What time will you be in? |
| **Richard** | Six. |
| **Clarissa** | Another committee? |
| **Richard** | Yes – the Armenians! |
| – | Or was it the Albanians? |
| **Clarissa** | See you then. |
| **Richard** | Don't forget – one hour's complete rest after luncheon. |

*He leaves her.*

*She stands alone for a moment, considering the flowers.*

**Clarissa**    Lucy!

Lucy?

*Lucy enters.*

**Lucy**    Yes, ma'am?

**Clarissa**    Would you find a place for these?

**Lucy**    Of course.

**Clarissa**    Thank you.

**Lucy**    And would you like me to see to your dress?

**Clarissa**    No, no, you've quite enough on your hands
already. But thank you, Lucy. Thank you.

–    Thank you, thank you, thank you, thank you,
thank you.

–    Thank you for helping me be like this, to be what
I want.

–    Thank you for liking me.

–    For seeming to like me.

–    For liking me.

–    Year by year my share is sliced –

–    And yet thank you for helping me to be like this,
to be what I want.

**Lucy**    Nothing else, ma'am?

**Clarissa**    No, that is all. I shan't be taking any visitors.
Thank you.

| – | Thank you for liking me. |
|---|---|
| **Lucy** | Call if you need us. |
| – | Year by year her share is sliced – look how little what remains to her is still capable of stretching, of absorbing, as in the youthful years, the colours, salts, shades of existence, so that she fills the room she enters. |
| **Clarissa** | Fear no more the heat of the sun. |
| – | Fear time itself – withdrawing, collapsing, year by year. |
| – | Like a nun withdrawing, or a child exploring a tower, she goes upstairs. |
| – | Fearing the emptiness about the heart of life – an attic room. |

*Clarissa enters her attic room:*

| **Clarissa** | Let's see now… |
|---|---|

*Big Ben begins to strike 11.30 – the leaden circles dissolve in the air.*

*She sits with her dress to examine herself in the mirror:*

| *Clarissa* | Here it is. Here. It. Is. Fear? Disgust? Resentment? And yet – and yet how many million times have I seen this face? And always with this same imperceptible contraction – see – this pointedness – this look of being seen. It is to give my face a point, a purpose. That is me – pointed, dartlike, definite. That is me – when some effort draws the parts together, makes a meeting-point. |
|---|---|

I have just broken into my fifty-second year.
Months and months of it remain untouched. June,
July, August! And I can see what I lack – it is not
beauty, no, it is not mind, no. And I am not old
– yet. It is – … something central that stretches
– no – *absorbs*, melts – yes, something warm that
melts, that breaks up surfaces and ripples the cold
contact of man and woman, or of women together.

*Sally enters.*

Some 'passion' – that I lack. That I can see. That I
do resent.

**Sally**    And Lord you should resent it.

**Clarissa**    Must I?

**Sally**    Yes! Go ahead! Since you've lost it – a warmth, a
passion – lost something at any rate – and since,
perhaps, your attitude to life has become a touch
sentimental.

**Clarissa**    My attitude to life?

**Sally**    Yes! After all I'm here, aren't I? – After all these
years. Well – what?

**Clarissa**    Sally.

**Sally**    What?

**Clarissa**    I suppose there was nothing at all 'sentimental' in
the way we used to talk?

**Sally**    No.

**Clarissa**    'Change the world!' – 'Abolish private property!'
– 'Avoid marriage!' – the catastrophe of marriage
– 'Avoid men!' – 'Universal love!' –

| | |
|---|---|
| ***Sally*** | I meant every word. |
| | ***Sally*** *lights a cigarette.* |
| ***Clarissa*** | You can't smoke in here. |
| ***Sally*** | I'm not 'in here'. What is this room anyway? |
| ***Clarissa*** | My bedroom. |
| ***Sally*** | And where does 'Mr Wickham' sleep? |
| ***Clarissa*** | Downstairs. |
| ***Sally*** | A-ha. I see, I see. |
| ***Clarissa*** | I don't think you do. I was quite unwell for a time. I needed rest. |
| ***Sally*** | Yes, rest. There's nothing restful about it, is there? |
| ***Clarissa*** | About what? |
| ***Sally*** | Sex – with one's husband. And what is that? |
| ***Clarissa*** | My dress – it's my dress for my party. |
| ***Sally*** | What a queer colour – such things they make us wear nowadays! |
| | |
| ***Clarissa*** | Is it all over for me? |
| ***Sally*** | Clarissa! If it is, you're managing very well. |
| ***Clarissa*** | But today, thinking of you, all day, and now – I think it might be. |
| ***Sally*** | I think it might be too. But as we are a doomed race, chained to a sinking ship, as the whole thing is a bad, bad joke, let us, at any rate, do our part |

36

– mitigate the sufferings of our fellow-prisoners, decorate the dungeon with flowers and books, be as decent as we possibly can. Those monsters, the Gods with their divine minions, will never lose a chance of hurting, of spoiling and containing human lives, but they are seriously put out if, all the same, you behave like a human being – and they shan't have it all their own way.

*They kiss.*

**Sally** *moves away.*

\- If it were now to die, 'twere now to be most happy.

\- That kiss on the terrace at Bourton – to be remembered always – a gift wrapped up, which she was just to keep, not to look at, but to keep always –

\- Or Sally's way with flowers, for instance –

\- Or the dressing-table – doing her hair in a kind of ecstasy –

\- The white dress – coming down in the pink evening light in that dress to meet her –

\- Or the bicycle – riding together on that bicycle round the parapet on the terrace –

\- That voice – which makes everything sound fantastical, which carries further than she knows or further than she cares to know –

\- That laughter – as she runs along the passage naked and the housemaid screams.

\- 'Suppose any of the gentlemen had seen?'

-         Or the first time – the first time – Sally sat on the
          floor with her arms round her knees, smoking a
          cigarette.

-         'Who is that?'

-         That.

-         'That is Sally Seton.'

-         'Her parents do not get on.'

-         How marvellous – that one's parents should not
          get on!

-         'She has French blood in her veins –'

-         'An ancestor had been with Marie Antoinette, had
          his head cut off, left a ruby ring –'

-         'Which she pawned the first day she came to stay
          at Bourton –'

-         'Without a penny to her name – '

-         That is Sally Seton.

-         Sitting, smoking, speaking, writing, thinking,
          laughing, running, fighting –

-         And the kiss – to remember always –

-         And Peter interrupting them on the terrace.

-         'Star gazing?'

-         Was that it?

-         Interrupting them out on the terrace.

-         But the memory –

| | |
|---|---|
| – | And how she had stood on her bed, in the middle of the night, and had yelled – |
| **Clarissa** | She is beneath this roof! SHE IS BENEATH THIS ROOF! |
| – | Fear no more, says the heart. |
| – | Committing its burdens to some sea, which sighs collectively for all sorrows. |
| – | And renews. |
| – | Begins. |
| – | Collects. |
| – | Lets fall. |
| **Clarissa** | And I cannot say of myself now: I am this, I am that. But losing that, I do resent. This room being an attic, the bed narrow, the sheets stretched. |
| – | And losing that, she did resent. |
| – | Narrower and narrower her bed would be. |
| – | She had gone up into the tower and left them blackberrying in the sun – |

*The front doorbell – on the street **Peter** waits:*

| | |
|---|---|
| **Peter** | If they were honest with themselves everyone would admit it: after the age of fifty, one hardly needs people any more. Life itself, every moment of it, now, in the sun, in Westminster at her doorstep, is enough – is too much, even! And people? They are certainly too much! And yet, |

you see, here I am, once again, starting again after thirty years – trying to explain Clarissa.

*Lucy answers.*

| | |
|---|---|
| **Lucy** | Good morning? |
| **Peter** | Good morning – is Mrs Dalloway at home? |
| **Lucy** | She is upstairs – occupied. Can I take a message? |
| **Peter** | I should like to see her. |
| **Lucy** | I'm afraid she's not taking visitors. |
| **Peter** | She will see me. |

*He brushes past.*

| | |
|---|---|
| **Lucy** | Excuse me, sir! She is not taking visitors. |
| **Peter** | But she will see me! |
| **Lucy** | Sir! |

*He passes through the house.*

| | |
|---|---|
| *Peter* | After five years in India, she will see me! I may have been half way round the world but I always come back to her – up here in her tower, getting ready for some party – |

*Peter enters her room.*

| | |
|---|---|
| **Peter** | Clarissa! |
| **Clarissa** | But – Peter! How wonderful! |
| **Peter** | Hullo. |
| **Clarissa** | Hullo! |

40

|   |   |
|---|---|
| – | She had not read his letter. |
| **Clarissa** | Oh but come in, come in! I only just got home myself. |
| | *Lucy enters.* |
| **Lucy** | Mrs Dalloway, I am – |
| **Clarissa** | It's quite alright, Lucy – a very old friend. |
| | *Lucy leaves them.* |
| **Peter** | You look surprised. |
| **Clarissa** | But I *am* surprised! |
| **Peter** | My last letter? |
| **Clarissa** | 'I may be back in London this summer'? |
| **Peter** | The one after that – |
| **Clarissa** | Yes – |
| **Peter** | I wrote later to say I would be coming in June. |
| **Clarissa** | And it is June! |
| **Peter** | So here I am! |
| **Clarissa** | Here you are! God. My dear Peter. |
| *Peter* | You have grown older – hard – |
| **Clarissa** | How are you? |
| *Peter* | But there is no bitterness in you – never – |
| **Clarissa** | It is so heavenly to see you again. |

| | |
|---|---|
| *Peter* | You're enchanting – cold and hard but perfectly enchanting. |
| **Clarissa** | Peter? |
| **Peter** | Yes – yes, I mean, and you. |
| **Clarissa** | Have you been here long? |
| **Peter** | I reached town last night. |
| **Clarissa** | But you could have stayed here! |
| **Peter** | I'm at a hotel over in Bloomsbury. |
| | Do you know – you're the only soul in London who knows I'm here! |
| **Clarissa** | What a blessing! |
| *Peter* | Shall I tell her? Put it all before her. |
| **Clarissa** | You look a little tired. |
| **Peter** | I am, yes. The journey was exhausting, but I had to see you right away – |
| *Peter* | Had to see you – and now will I tell you? And place it all before you and let the old emotion rise and rise and ask you – |
| **Peter** | How is everything, how are you, how is everybody – Richard? Elizabeth? |
| **Clarissa** | Well – they're very well. Richard's at a committee. |
| **Peter** | Of course. Good. And what's all this? |
| **Clarissa** | I'm fixing a dress for this party tonight. |
| **Peter** | Party? What party? |

| | |
|---|---|
| **Clarissa** | Oh my dear Peter – sit down! There. |
| | You won't mind if I work on this? |
| **Peter** | No, please. |
| **Clarissa** | We're giving a party this evening, which I shan't invite you to, / since – |
| **Peter** | Since I hate parties. |
| **Clarissa** | There we are then. |
| *Peter* | But if I say it she will think me ridiculous! Always, even as a girl, there was this timidity in you, and amidst the cruelty of marriage it has become this – this coolness – and you would laugh at me – |
| **Clarissa** | And you – what has happened to you? |
| **Peter** | Millions of things! |
| **Clarissa** | But what are you doing here? |
| **Peter** | What am I doing here? |
| **Clarissa** | Back here, I mean, in London. |
| **Peter** | Well – you see – I am in love – |
| | In love with a girl in India. |
| **Clarissa** | In love! |
| *Peter* | There it is. There it all is. I have that and that is all. |
| **Clarissa** | Is she here? |
| **Peter** | No, no – married, unfortunately, the wife of a major in the army – I'm here to see lawyers about the divorce, Hooper and Grateley are going to sort it for us – |

| | |
|---|---|
| **Clarissa** | But who is she? |
| **Peter** | Daisy. Her name's Daisy. She is everything, Clarissa – really. |
| *Peter* | She is not you, but there it is – |
| **Peter** | She has a little boy and a girl. I could not love them all more. I have not felt so young for years! |
| **Clarissa** | That's – how wonderful. And you will settle back here? |
| **Peter** | I hope so. I know I shall have to find work – I shall have to ask a Hugh Whitbread or a somebody to mention my name to so-and-so – |
| **Clarissa** | I will speak to Richard. |
| **Peter** | No, don't – don't, please. There's no need. |
| *Peter* | That's what I'm up against. Dalloway and all the rest of them. |
| **Clarissa** | But I am so glad you shall be back here – after – everything – |
| **Peter** | So am I. |
| | |
| **Clarissa** | It is just so extraordinary… |
| **Peter** | What? |
| **Clarissa** | To see you! *You*, I must say – today of all days – now – when I have been thinking of Bourton all morning. |
| **Peter** | One of those mornings. |

| | |
|---|---|
| **Clarissa** | Yes! Yes... Do you remember the lake in the evenings? |
| **Peter** | Yes. Yes, yes, yes. Of course I do. |
| *Peter* | Always – sitting with you – ashamed, somehow – on the terrace, ghastly beautiful with light from the sunken day. |
| **Clarissa** | The lake in the evenings – oh, and the flowers! You remember – Sally used to cut flowers' heads off and drop them straight / in the bowls – |
| **Peter** | In the water bowls. Yes! And your aunt said, 'How would she like it if a flower cut her head off?' |
| | Have you been back? |
| **Clarissa** | No. Actually, she has it now – Aunt Helena. I never go there anymore. |
| **Peter** | Your father? |
| **Clarissa** | Passed a few years ago, I wrote – |
| **Peter** | Yes of course you did, you did. I often wish I'd got on better with him. |
| **Clarissa** | But he never liked any one who – |
| *Peter* | Loved his daughter – |
| **Clarissa** | Read a word of William Morris in public. |
| **Peter** | Yes, that's true. |
| *Peter* | Why must we go back like this into the past? Why now? Why after everything? Why helplessly? Dragged back always to that final scene by the fountain at Bourton – here – |

45

*Pivot back to Bourton thirty years ago:*

| | |
|---|---|
| – | Which he believes even now has mattered more than anything else in the whole of his life. |
| – | Really? |
| – | Yes. Bourton. May. 1892. A Friday. Three o'clock in the afternoon. |
| **Peter** | Sally gave you my note? |
| **Clarissa** | 'Something very important has happened'. |
| **Peter** | That's it. Something has happened. |
| **Clarissa** | What is it? Peter? |
| | Father will want us in for tea soon. |
| **Peter** | Must you be so cruel. |
| **Clarissa** | Peter. |
| **Peter** | I want the truth – this – Mr Wickham – |
| **Clarissa** | His name is Dalloway, we've had quite enough of that feeble joke – |
| **Peter** | So you have an understanding then? Tell me the truth. |
| **Clarissa** | Please, Peter – |
| **Peter** | Tell me the truth. |
| **Clarissa** | Peter – it's no use. |
| **Peter** | Tell me the truth. |

| | |
|---|---|
| *Clarissa* | There's the truth – it's no use, truly. |
| *Peter* | The perfect hostess. |
| *Clarissa* | What's that? |
| **Peter** | You'll be the perfect hostess. |
| – | He meant her to feel it. |
| *Clarissa* | I do hope so. |
| **Peter** | Clarissa! |
| – | The death of the soul. |
| **Peter** | Clarissa! |
| – | It is all over for her. |
| – | The sheet became stretched and the bed became narrow. |
| – | She has gone up into the tower and left us blackberrying in the sun. |
| *Peter* | The door has shut. I have been a fool – a failure. |
| | *Return to the attic room:* |
| – | All the same – all the same – now, at least, he is in love again. That is all. |
| **Peter** | It is so wonderful to be in love again – |

| | |
|---|---|
| **Clarissa** | Yes? |
| **Peter** | Yes. |
| **Clarissa** | Peter – |
| **Peter** | What does one do it for? |
| **Clarissa** | What? |
| **Peter** | These parties! |
| **Clarissa** | Oh. |
| | They're an – offering, I suppose. |
| **Peter** | An offering? |
| **Clarissa** | Yes. Yes, an offering. That may sound horribly vague – |
| **Peter** | It does. |
| **Clarissa** | But that is what I do it for. |
| **Peter** | Are you happy, Clarissa? Does Richard / make you – |
| | *Elizabeth enters.* |
| **Clarissa** | Here is my Elizabeth! |
| **Elizabeth** | Hullo mother. Oh – how d'you do? |
| **Peter** | Hullo Elizabeth. |
| **Elizabeth** | Hullo. |

| | |
|---|---|
| **Clarissa** | Aren't you taking your lesson with Miss Kilman? |
| **Elizabeth** | We're just about to start. |
| **Clarissa** | Very good. You remember Peter Walsh? |
| **Elizabeth** | I'm not sure that I do. |
| **Peter** | And I'm afraid we shan't now get the chance to become acquainted. I must be off. Goodbye Elizabeth. Goodbye Clarissa. |

*Peter leaves.*

| | |
|---|---|
| **Elizabeth** | Goodbye! |
| **Clarissa** | *(Calling.)* Peter! My party tonight – remember my party tonight! |
| – | Remember my party tonight, remember my party, remember my party… |

*Out on the street:*

| | |
|---|---|
| **Peter** | Such a fool! Called before seeing anyone else, 'the only soul who knows I'm here' – told her everything – everything, as usual, as usual – made a statue of Daisy and put it between us for her to admire – a damn fool, trying to explain Clarissa again. |
| – | Remember my party tonight! |
| **Peter** | No, no – trying to explain myself to her again. But that is the damn mystery of it – a meeting with Clarissa – always sharp and uncomfortable – and yet in the most unlikely of places, it will flower out, open, shed its scent, reveal something, after years of lying lost. |

–        MY PARTY TONIGHT!

*In Regent's Park:*

**Peter**        But why must I think of my childhood now?
Why go back and further back? The result of
seeing her, of course – mending her dress, going
to parties – and of walking in Regent's Park, as I
used to when I was a boy.

They might consider me a failure – later they will
sit – the Dalloways and the Whitbreads – and
they will consider me a failure – but no – I care
not a straw –

**Maisie**        Regent's Park tube station?

**Peter**        Just over there.

**Maisie**        Thank you.

**Peter**        Still, I have escaped – I am utterly free. And all
the while, the sun is hot – and in the end one gets
over things – and life after all has a way of adding
day to day – and there – if *that* is being young – to
be having an awful scene on the edge of Regent's
Park – then I am glad to be finished with it.

**Rezia**        But I am so unhappy, Septimus.

**Peter**        To be shouting about unhappiness on a fine
summer day –

**Septimus**        For God's sake don't come!

**Peter**        If that is being young – to have gotten into some
fix –

**Rezia**        Please – Septimus!

| | |
|---|---|
| *Peter* | To be squabbling under a tree – then I am glad to have finished with it. |
| **Rezia** | Septimus, let us go now. |
| **Septimus** | No! Stay back! |
| *Rezia* | It is a silly, silly dream – this being unhappy. I am finished with it. I will stop somebody, anybody in the street, and I will say to them: I am unhappy. I will scream! People must notice. People must see. People – yes, you are just 'people' now, the English people, with your children and your horses and your ugly clothes – and you must notice that something has happened. My husband has said he will kill himself. A terrible thing to say. And Dr Holmes has not saved him. And I cannot sit beside him when he stares so and does not see me and makes everything terrible. But to love makes one solitary – I can tell nobody. 'Septimus has been working too hard.' 'Septimus is tired.' 'Septimus must rest.' That is all I can say. That is all I can write, to my own mother. I am his wife and I will never, never tell that he is mad. I cannot even tell Septimus now. He does not see me. He is happy without me. And yet – nothing could make me happy without him – nothing! He has fought, he is brave, he is not Septimus now, he has gone mad – but he is not mad – in Italy he was not mad! But far is Italy, and the white houses, and the little room where my sister sat making hats, and the streets crowded every evening with people walking, laughing aloud, not half alive like the people here – for you should see the Milan gardens! |

*A memory from Italy:*

**Septimus**    The gardens? Is that an invitation?

**Rezia**    An invitation, yes! Put down your book. I am very tired of all this hat-making for today. You must also be tired of your book, no?

**Septimus**    Yes – in fact, I think I'm finished with it for today.

**Rezia**    But what is it that you are reading?

**Septimus**    Dante.

**Rezia**    Dante! *Oddio!* You just come out of war and you sit reading Dante! You Englishmen are funny men.

**Septimus**    I don't think many Englishmen spend their afternoons like this.

**Rezia**    No? Then you are a funny man, Seargent Warren Smith.

**Septimus**    It's Septimus.

**Rezia**    Lucrezia.

**Septimus**    Very pleased to meet you, Lucrezia.

**Rezia**    *La passeggiata?*

**Septimus**    Yes, of course. Where's your father?

**Rezia**    He is sleeping in his bedroom – we have no visitors today but you soldiers. *Andiamo* – oh but you English – you are so silent, so serious! What will we talk about?

**Septimus**    Whatever you like.

| | |
|---|---|
| *Rezia* | Oh no, no, but I like the silence – I respect you Englishmen with your silence – it is a gentle silence, I think – I hope if I will see London it will be full of this silence. |
| *Septimus* | Ah – I'm afraid you may be disappointed. |
| *Rezia* | But if I am disappointed then I will just go shopping– I have heard there are so many wonderful shops all over London – in Soho, yes? |
| *Septimus* | Close enough. |
| *Rezia* | Hat shops? |
| *Septimus* | Yes, a few. Though none to match yours. |
| *Rezia* | Aha! It is the hat that matters most, Mr Septimus, you will see. How do you like Milan? |
| *Septimus* | I like it very much. It is a refuge. |
| *Rezia* | And you are needing a refuge? |
| *Septimus* | I think so, yes. |
| *Rezia* | I think so too. Come with me – you should see the gardens. |
| | *Returning to the present:* |
| **Rezia** | You should see the Milan gardens. |
| *Rezia* | Who should? There is no one. |
| *Septimus* | No. I will not go mad. |
| *Rezia* | No one to talk to. |

53

| | |
|---|---|
| *Septimus* | The message, what is the message? |
| *Rezia* | Not even Septimus. |
| *Evans* | The birth of a new religion – love, universal love. |
| *Septimus* | But one must be scientific – |
| *Evans* | That's right, above all scientific – and in the streets now brutality blares out on placards, men are trapped in mines – |
| *Septimus* | Boys march in uniform – |
| *Evans* | Women are burnt alive, and sick people are paraded for the entertainment of the public – who laugh, laugh, laugh out loud – and it is *you* who has gone mad? |
| *Rezia* | But I must go back to him. |
| *Evans* | She is returning. Tell her the truth, Septimus – that human beings have neither kindness, nor faith, nor charity – |
| *Septimus* | She will not hear it – |
| *Evans* | They hunt in packs. |
| *Septimus* | She doesn't see. |
| *Evans* | Their packs scour the desert for converts and vanish screaming into the wilderness – and they desert us – the fallen. |
| **Rezia** | Septimus? |
| *Evans* | The dead are waiting in Thessaly. |
| **Rezia** | Septimus, stop this, please. The time, Septimus – what is the time? |

| | |
|---|---|
| *Evans* | It is late. The world is old. |
| **Septimus** | It has bred in us all a well of tears. |
| **Rezia** | What are you saying, Septimus? The time – please – what is the time? |
| **Septimus** | The time. |
| *Evans* | And now the giant mourner – |
| **Rezia** | Yes! |
| *Evans* | Will give you the truth – |
| **Septimus** | I will give you the time – |
| *Evans* | He has come to tell you of his revelation – |
| **Rezia** | Yes? |
| **Septimus** | I will tell you the time – |
| *Evans* | First that trees are alive – next there is no crime – next love, universal love – |
| | *Big Ben strikes 12. The leaden circles dissolve in the air.* |
| **Septimus** | It is noon. |
| **Rezia** | Yes – that's it – now is our appointment, you remember? Down this way, quickly. Build it up – |
| **Septimus** | First one thing, then another. |
| **Rezia** | That is it! Yes! We must be quick, or we will be late for Sir Bradshaw. |
| *Septimus* | Build it up. |
| *Rezia* | First one thing. |

| | |
|---|---|
| *Septimus* | Then another. |
| **Rezia** | He is going to help you, Septimus. |
| *Rezia* | His name being a kind name – Sir William Bradshaw – he will help us – |
| **Rezia** | He will help us both. |
| **Septimus** | Dr Holmes? |
| **Rezia** | No, not Holmes. Sir William Bradshaw. We will walk like we did in Milan – |
| *Rezia* | Before the panic was on you – that you cannot love – cannot feel. And you propose to me one evening when that panic is on you. And you did not hide your feelings – there were none to hide. You hid that from me. / And the panic stayed on you. |
| *Septimus* | And the panic stayed on me. I lied. And then once you stumble – the game's up – human nature is on you – Holmes is on you – to force your soul – Holmes and then – |
| **Rezia** | This must be the house. Look – how expensive that motorcar must be – |
| *Bradshaw* | Indeed it is! Low, powerful, grey, with – you see – my own initials interlocked on the panel, and as the body is grey so too is the interior – heaped with grey furs, silver rugs, to keep her ladyship warm whenever I must travel some sixty miles or more down into the country to visit the afflicted who can afford the very reasonable fee which I very properly charge them for my advice and her ladyship is kept waiting in the car with the rugs about her knees an hour or more – |

| | |
|---|---|
| ***Lady Bradshaw*** | Leaning back, thinking sometimes of the patient, sometimes, quite excusably, of the wall of gold, mounting minute by minute, until I feel wedged on a calm ocean, with scarcely anything left to wish for – I have a boy doing well at Eton, though I would have liked a daughter too, and interests I have in plenty – child welfare, the after-care of the epileptic, and photography, so that if I see a church decaying, I bribe the sexton, get the key and take photographs – |
| ***Bradshaw*** | Which are scarcely to be distinguished from the work of professionals – and though I am myself no longer young, I have worked very hard, and I have won my position by sheer ability, and I have been gifted a reputation – a reputation not merely of lightning skill and almost infallible accuracy in diagnosis, but of sympathy, tact, understanding of human nature. And so I can see, the moment the Warren Smiths enter the room that this is a case of extreme gravity – |

*They enter the house:*

| | |
|---|---|
| **Bradshaw** | But fear no more, Mrs Warren Smith. I know how to handle such cases. |
| **Rezia** | He is not himself today. |
| **Bradshaw** | That's quite alright. Please have a seat. |
| **Rezia** | Thank you. |
| **Bradshaw** | How are you feeling Mr Warren Smith? |
| **Septimus** | It is late. |
| **Rezia** | Septimus – |

| | |
|---|---|
| **Bradshaw** | Mr Warren Smith? My name is Sir William Bradshaw. I am here to help you. I understand you have been feeling rather unwell of late. |
| **Rezia** | That's right. |
| **Bradshaw** | You served with great distinction during the war? |
| **Septimus** | War. |
| **Rezia** | Yes, he served with the greatest distinction. He was promoted. |
| **Bradshaw** | And they have the very highest opinion of you at your office? I have a glowing letter here from Mr Brewer, your manager. So that you have nothing to worry you – no financial anxiety – nothing? |
| **Septimus** | I have – I have – committed a crime. |
| **Rezia** | No, no, he has done nothing wrong whatever. Septimus. |
| **Bradshaw** | That's alright Mrs Warren Smith. I understand. Let us have a little talk in the next room while your husband waits here. Would that be alright? |
| **Rezia** | Yes, of course. Septimus – wait here – |
| | *Rezia and Bradshaw move to one side:* |
| **Bradshaw** | You have been seeing another consultant? |
| **Rezia** | Yes – a Dr Holmes. |
| **Bradshaw** | For how long? |
| **Rezia** | Six weeks. |

**Bradshaw**   Proscribed a little bromide?

**Rezia**   That's correct.

**Bradshaw**   Anything else?

**Rezia**   No. Dr Holmes has told Septimus to communicate –

**Bradshaw**   To 'communicate'?

**Rezia**   Yes, 'communication is health'.

**Bradshaw**   I see…

**Rezia**   And a hobby – he said it was good for Septimus to 'throw himself into outside interests'.

**Bradshaw**   Dear oh dear…

**Rezia**   That is not right?

**Bradshaw**   It is far less than right. Mrs Warren Smith – I am afraid I could see from the moment you walked in this is a very severe case – quite advanced – a case of complete nervous breakdown.

**Rezia**   Breakdown?

**Bradshaw**   Yes. It is not a question of communication, nor of outside interests. It is a question of rest. He has talked of killing himself?

**Rezia**   That's correct. But Dr Holmes said that this was only to frighten me –

**Bradshaw**   No, no, no – I am afraid Dr Holmes has been severely mistaken. You were right to come and see me. Your husband must rest, Mrs Warren Smith, until he has recovered.

**Rezia**   I must keep him at home?

**Bradshaw**     Not at your home no. I have a friend who runs a delightful home down in the country where he will be perfectly looked after.

**Rezia**     Away from me?

**Bradshaw**     The people we care for most are not good for us when we are ill.

**Rezia**     We will be separated?

**Bradshaw**     There's no alternative.

**Rezia**     But he is not mad, is he?

**Bradshaw**     Mrs Smith, please – I never speak of madness – it is called not having a sense of proportion.

*Proportion*     A sense of proportion, Lucrezia Warren Smith. When a man comes into your room and says he is Christ (a common delusion) and he has a message (as they mostly have) and he threatens (as they often do) to kill himself – he has lost his sense of proportion.

**Rezia**     But this home – there are doctors there?

**Bradshaw**     Several yes, and nurses, he will be amply cared for.

**Rezia**     He will refuse – he hates doctors.

**Bradshaw**     I am afraid he rather needs us at the moment.

**Rezia**     But then he needs me also – he will be all alone – who will –

**Bradshaw**     Mrs Smith. Your husband has threatened to kill himself. There is no alternative. It is a question of law. He will lie in bed in a beautiful house in the Surrey countryside and before too long he will be himself again.

| **Proportion** | Health he must have and health is proportion. I, Divine Proportion, am Sir William's goddess – together we have made England prosper, secluded her lunatics, forbade childbirth, penalised despair, made it impossible for the unfit to propagate their views until they, too, share in his faith in me. So that not only, thanks to me, do his colleagues respect him, his subordinates fear him, but relations of his patients feel for him the keenest gratitude for insisting that these little prophetic Christs and Christesses should drink milk in bed, rest in solitude, for six months, until a man who went in weighing seven stone six comes out weighing twelve. You will soon be endeared to him and know this gratitude. |
|---|---|
| **Rezia** | I see. |
| **Bradshaw** | Very good. Now, I do not wish to hurry you but if you have no further questions perhaps we may return to your husband. |

*They step back to see* **Septimus**.

| **Bradshaw** | Well now, we have had our little talk. |
|---|---|
| **Rezia** | He says you are very, very ill. |
| **Bradshaw** | Mr Smith – we have been arranging that you should go into a home. |
| **Septimus** | One of Holmes's homes? |
| **Bradshaw** | One of *my* homes, Mr Smith, where we will teach you to rest. You need no longer see Dr Holmes at all. |
| **Septimus** | The message – now – the revelation – |

| | |
|---|---|
| **Rezia** | It is in the countryside. |
| **Bradshaw** | That's right, Mrs Smith, in the English countryside. If you would just sign here and here then I shall make all the arrangements and you can begin to regain a sense of proportion. |
| | Good. There is just one thing more. I am quite certain that you should be the last man in the world who would wish to frighten his wife, but you have talked of killing yourself. |
| **Septimus** | That is my own affair. |
| **Bradshaw** | And your wife's. |
| *Proportion* | Septimus Warren Smith – this living or not living is not an affair of our own. |
| **Bradshaw** | Nobody lives for himself alone. Listen, Mr Smith, we all have our little moments of depression – there is nothing to fear – you have a brilliant career ahead of you, and if these impulses should come upon you sometimes then try to maintain a sense of proportion. |
| **Septimus** | I – ... I – ... |
| **Bradshaw** | Yes? |
| **Septimus** | I – ... I – have a... I have a / message – |
| **Bradshaw** | Try to think of yourself as little as possible. You understand? Trust everything to me. I will send a nurse to you at five this evening. Now – if you'll excuse me, I have some further business to attend to. Good day, Mr and Mrs Smith. |

62

**Proportion**   Behold! It is this combination of decision and humanity that has endeared Sir William so greatly to the relations of his victims.

**Rezia**   I do not like that man.

*Rezia* and *Septimus* *return to the street.*

**Proportion**   Yet you will come to admire him.

*Rezia*   But has he not failed us?

*Proportion*   Failed? *Failed?*

*Rezia*   Yes! See – we are alone again.

*Proportion*   Lucrezia Warren Smith, if Sir William Bradshaw and his reputation and the police and the good of society *fail* your husband? Well then – I have a sister –

*Rezia*   A sister?

*Proportion*   She is called Divine Conversion, the fastidious Goddess –

*Conversion*   And though I am now engaged in the heat of India, the sands of Africa, and the slums of London, wherever – in short – the climate or the devil tempts men to fall from the true belief which is my own – I may yet return, swoop, shut people up, and devour them.

*Rezia*   But you will not help us! You will break him!

*Proportion*   He is already broken, Lucrezia.

*Conversion*   And we will take care, down in Surrey, of these unsocial impulses –

| | |
|---|---|
| *Proportion* | Which are bred more than anything by the lack of good blood – |
| *Conversion* | And as I love blood better than brick – |
| *Proportion* | She will feast most subtly on the human will – |
| *Conversion* | Until the defects of your soul are corrected – |
| *Proportion* | Until the weak break down, sob, submit – |
| *Conversion* | Until the image of myself has been stamped indelibly on the sanctuaries of others – |
| **Septimus** | Lucrezia? |
| **Rezia** | Yes, Septimus? |
| **Septimus** | Can we go home? |
| **Rezia** | Yes. Of course, my love, let us go home. |
| – | Shredding and slicing, dividing and subdividing, the clocks of Harley Street nibble at the June day – |
| | *Big Ben strikes 1. The leaden circles dissolve in the air.* |
| – | WE SUGGEST SUBMISSION. |
| – | WE UPHOLD AUTHORITY. |
| – | WE RECOMMEND FAITH IN DIVINE PROPORTION. |
| **Septimus** | No! We are going home. I am not afraid. Every moment nature gives me a hint – there, there, there – I see her determination to show me courage and freedom in the burst of a fountain, in the rush of feet on the street, in the trees dragging their leaves like nets through the depths of the grey-blue afternoon air, beautifully, always |

beautifully, she stands close up to breathe through her hollowed hands Shakespeare's words, her meaning –

–    Fear no more the heat of the sun,

–    Nor the furious winter's rages,

–    Thou thy worldly task hast done,

–    Home art gone, and taken thy wages:

–    Golden lads and girls all must,

–    As chimney-sweepers, come to dust.

–    Fear no more, says the heart in the body.

–    Committing its burdens to some sea, which sighs collectively for all sorrows.

–    And renews.

–    Begins.

–    Collects.

–    Lets fall.

–    Such fools we are, for heaven knows what one does it for – making it up, building it round one, tumbling it, creating it every moment afresh –

–    But life is good – the sun is hot – food is pleasant – life is good.

–    And that one day should follow another: Wednesday, Thursday, Friday, Saturday.

|   |   |
|---|---|
| – | That one should wake up in the morning – wake up and see the sky, walk in the park, meet Hugh, then suddenly in comes Peter – it is enough. |
| – | It is enough. |

*Return to **Clarissa** at home:*

|   |   |
|---|---|
| **Clarissa** | That's what I do it for. |

***Elizabeth** enters.*

|   |   |
|---|---|
| **Elizabeth** | Mother? |
| **Clarissa** | Yes? |
| **Elizabeth** | Miss Kilman and I are going out to the Stores. |
| *Elizabeth* | Miss Kilman and mother hate each other. |
| **Clarissa** | Have you finished your lesson? |
| **Elizabeth** | Yes, just now. |
| *Clarissa* | And they have been closeted all this time upstairs. All this time. |
| **Clarissa** | And where is our dear Miss Kilman? |
| *Clarissa* | Sweating, praying, eavesdropping. |
| **Elizabeth** | Out on the landing. |
| *Clarissa* | In that mackintosh with that umbrella. |
| **Clarissa** | Miss Kilman? |
| *Doris* | Yes. I am hiding on the landing. And I am wearing a mackintosh. But I have my reasons. First, it is cheap. Second, I am over forty, and I do not, after all, dress to please since, third, no |

clothes suit me. And anyway I will never come
first with any one since, fourth, I am ugly – I
cannot help being ugly – do my hair as I like my
forehead resembles an egg. Fifth, I am poor. I am
degradingly poor. I cannot afford to buy pretty
clothes. If I was not poor I would not be here
taking jobs from people like this – people who
like 'to be kind'. Mr Dalloway, to be fair, has been
kind. But Mrs Dalloway has not been kind. She
has been merely condescending. She comes from
the most worthless of all classes – the rich, with
a smattering of what they call culture. I have a
perfect right to anything that the Dalloways do for
me. And so I will stay strong and put my faith in
God. And I will wear my mackintosh. And I will
not make myself 'agreeable'.

**Clarissa**    Miss Kilman? Do come in.

*Doris enters the room.*

**Doris**    Good afternoon Mrs Dalloway.

**Clarissa**    Good afternoon Miss Kilman.

*Doris*    And here she is – cutting me up and sticking me
together again.

**Elizabeth**    Where's father?

**Clarissa**    Some committee – Albanians or something –

**Doris**    The Armenians.

*Doris*    My knowledge of modern history is thorough in
the extreme.

**Clarissa**    Yes, that's it. Thank you Miss Kilman.

| | |
|---|---|
| *Doris* | Unlike this woman who does nothing, thinks nothing, believes nothing – |
| **Clarissa** | You are taking Elizabeth to the stores? |
| **Doris** | I am. |
| **Clarissa** | You had better be going then. |
| *Clarissa* | And take my daughter with you – as always. |

| *Doris* | *Clarissa* |
|---|---|
| The cruellest thing in the world? Being thought clumsy, hot, domineering, hypocritical, jealous, cruel and unscrupulous by this woman, this fool, this simpleton – who is without faith – | The cruellest thing in the world? Seeing this clumsy, hot, domineering, hypocritical, jealous, cruel and unscrupulous woman, dressed in a mackintosh coat, taking my daughter with her – |

| | |
|---|---|
| *Clarissa* | Faith! Is this a Christian – this woman? *She* in touch with invisible presences! |
| *Doris* | She has known neither sorrow nor pleasure – has trifled her life away – |
| *Clarissa* | She know the meaning of life! Creeds and prayer and mackintoshes? |

| | |
|---|---|
| *Doris* | Cutting me up and sticking me together again. |
| *Clarissa* | Love and religion – how detestable they are. Have I ever tried to convert any one? Do I not wish everybody to be themselves? Even Kilman, in this mackintosh, who Heaven knows I would like to help – it is not her one hates but the idea of her. |
| **Doris** | Well. We had better be going. |
| **Clarissa** | Enjoy your afternoon. |
| **Doris** | Thank you. |
| **Clarissa** | Goodbye. |
| **Elizabeth** | Goodbye mother. |
| – | Cutting her up and sticking her together again. |
| | *Out onto the street:* |
| **Clarissa** | Oh – Elizabeth! |
| – | Cut up, beaten up, broken up – out on the street – |
| **Clarissa** | Elizabeth! |
| – | By the assault of carriages, the brutality of vans – |
| **Clarissa** | Remember the party! |
| – | Out on the street. The eager advance of angular men – |
| **Clarissa** | Remember our party tonight! |
| – | The flaunting women breaking upon the body of Miss Doris Kilman out on the street. |
| **Doris** | I have been cheated. |

| | |
|---|---|
| – | CHEATED! |
| **Doris** | Yes, the word is no exaggeration, for surely – |
| – | SURELY! |
| **Doris** | A girl has a right to some kind of happiness? And I have never been happy. Well, just as I might have had a chance of happiness at Miss Dolby's school, the War came and Miss Dolby said – |
| – | 'Might you be happier with people who share "your views" – |
| – | "Your Views." |
| – | About the Germans?' |
| **Doris** | And I had to go. |
| – | It was true that her family was of German origin – |
| – | Spelt the name K.I.E.H.L.M.A.N. in the eighteenth century – |
| – | But her brother had died for England. |
| – | And she would not pretend that the Germans were villains. |
| **Doris** | Not when I have German friends, not when the only happy days of my life have been spent in Germany. |
| – | Then the Lord came to her. She saw the light two years and three months ago. |
| **Doris** | Now I do not envy women like Clarissa Dalloway. I pity them. I pity – |
| – | And despise – |

| | |
|---|---|
| *Doris* | I pity and despise them from the bottom of my heart. |
| | *In the stores:* |
| **Elizabeth** | Here we are. What floor do we want? |
| – | Yet she has been cheated. Sometimes lately it had seemed to her that her food was all that she lived for – |
| **Doris** | Except for Elizabeth – |
| – | Except for Elizabeth, her food was all she lived for – |
| **Elizabeth** | Miss Kilman? |
| *Doris* | But one must fight; have faith in God; it was the flesh that one must control. The flesh! |
| **Elizabeth** | What department do you want? |
| **Doris** | The flesh. |
| **Elizabeth** | Miss Kilman? |
| **Doris** | Petticoats! Fourth floor. Forgive me, Elizabeth – you know when people are happy they have some reserves upon which to draw – but today I am like a wheel without a tyre, jolted by every pebble. Let us have our tea. |
| **Elizabeth** | Yes, of course. |
| **Doris** | And…a chocolate éclair? |
| *Doris* | The pleasure of eating is the only pure pleasure left to me. |
| **Elizabeth** | Why not. |

| | |
|---|---|
| **Doris** | My grandfather kept an oil and colour shop nearby. I should have liked to do more painting – if it had been allowed – oh but now, of course, all professions are open to you and other talented women of your generation: law, medicine, politics – but, as for myself, is it my fault that my career is absolutely ruined? |
| **Elizabeth** | Good gracious, no – of course not. |
| *Doris* | The kindness! – 'good gracious' – of this girl – good gracious! Who is so beautiful – who I genuinely love – |
| **Elizabeth** | It is rather stuffy in here. |
| *Elizabeth* | Her way of eating…eating with intensity – there is something – |
| **Doris** | Are you going to the party tonight? |
| *Elizabeth* | Something appalling – |
| **Elizabeth** | I suppose I will, mother wants me there. |
| *Elizabeth* | About her way of eating with such intensity – appalling. |
| **Doris** | You must not let parties absorb you. |
| **Elizabeth** | I shan't, I don't much like them. |
| *Doris* | She hates me. It is too much – to sit here unable to think of anything to say – to see her turning against me – repulsed by me – it is too much. |
| **Doris** | I never go to parties. |
| **–** | If she could hold her. |
| **Doris** | People don't ask me to parties. |

72

| | |
|---|---|
| *Doris* | If I could make her mine absolutely and forever and then die – |
| **Doris** | Why should they ask me? |
| *Doris* | But to sit here – in agony. |
| **Doris** | I'm plain. I'm unhappy. I don't pity myself. I pity – |
| – | Your mother – |
| **Doris** | Other people, more. |
| – | It is too much. |
| | |
| **Elizabeth** | One has to pay at the desk. |
| **Doris** | I've not quite finished yet. |
| **Elizabeth** | But it is so awfully hot in here, I should like to go for a walk. |
| **Doris** | Very well! |
| | Don't quite forget me! |
| **Elizabeth** | What ever do you mean? |
| *Doris* | I am repulsive. My knowledge of modern history is thorough in the extreme, but I am repulsive. |
| **Elizabeth** | I shall see you on Monday for our lesson. |
| – | It is too much. |
| | |
| **Elizabeth** | Goodbye Miss Kilman. |

| | |
|---|---|
| **Doris** | Goodbye Elizabeth. |
| – | Goodbye beauty. |

*On the street:*

| | |
|---|---|
| **Elizabeth** | Free! Free at last, and perhaps I need not go home just yet. I will ride like a pirate up the Strand on an omnibus. Oh why must Miss Kilman always talk of her sufferings? Why not just take pleasure in the fact that London is about to deliver to us a beautiful evening? |
| – | Like a woman who has slipped off her working dress and apron to array herself in blue and pearls, the day put off stuff, took up silk, began the slow change to evening. |
| – | I resign – |
| – | The sky seems to say – |
| – | I resign, I fade, I disappear – |
| – | But London will have none of it. |
| – | She rushes her bayonets into the sky, pins her there for our revelries. |

*The Warren Smiths at home:*

| | |
|---|---|
| – | And the evening light – beckoning, signalling – spills in upon the hand of Septimus Warren Smith and speaks – |
| – | Fear no more the heat of the sun. |
| – | Fear no more says the heart in the body. |
| – | But she fears this: to love makes one solitary. |

74

| Rezia | And 'the people we are most fond of are not good for us when we are ill.' I have not forgotten that – and any minute now Sir Bradshaw's nurse will be here to take him away. He is happy now, I suppose. Smiling. No but I cannot bear to see him smiling! It is not being my husband to look so strange like this, to lie on the sofa so silent hour after hour, and then to jump up and scream about dead men or to grab me and tell me to write, write, write – this drawer – it is full of writings, all about war, about Shakespeare, about some great discoveries, / about universal love, how there is no death, about Evans calling out – |
|---|---|
| *Septimus* | Universal love, there is no death, men must not cut down trees. There is a God. Change the world. No one kills from hatred. Make it known. |

| **Septimus** | What are you doing? |
|---|---|
| – | He is awake. |
| **Rezia** | You're awake. |
| – | Make it known. |
| **Septimus** | Yes. |
| **Rezia** | Making a hat for Mrs Peters. |
| **Septimus** | Mrs Peters? |
| **Rezia** | The married one next door. |
| **Septimus** | Mrs Peters? |
| **Rezia** | Yes. |

| | |
|---|---|
| **Septimus** | It looks too small. |
| **Rezia** | Do you think so? I suppose Mrs Peters is a big woman – |
| **Septimus** | You suppose? |
| **Rezia** | Oh but she has been so good to us, you know. She gave me grapes this morning. |
| **Septimus** | But the other day you caught her playing our gramophone. |
| **Rezia** | Yes! But she gave us grapes this morning. |
| – | But the visions, the faces, the voices, where are they? |
| – | Were they true? |
| **Septimus** | Was it true? |
| **Rezia** | What? |
| **Septimus** | The gramophone? She was playing the gramophone? |
| **Rezia** | Yes. I told you so the other day. |
| **Septimus** | You did, you did. She has a nasty tongue. |
| **Rezia** | I don't know about that. |
| **Septimus** | You told me so the other day! |
| **Rezia** | She can be unkind. |
| **Septimus** | Yes, yes she can. |
| **Rezia** | You think it is too small? |
| **Septimus** | What? |

| | |
|---|---|
| **Rezia** | The hat! |
| **Septimus** | Let me see. |
| **Rezia** | She chose it – kept telling me how her head was really very small – |
| **Septimus** | No measurements? |
| **Rezia** | No. And you see if it is no good I will have to start over again… What do you think? |
| **Septimus** | I think… |
| **Rezia** | Yes? |
| **Septimus** | It is the perfect hat – for an organ grinder's little monkey. |
| **Rezia** | Oh God. It is too small? |
| **Septimus** | Too small? My love, I can hardly see it. |
| **Rezia** | But she will be back this evening! |
| **Septimus** | With her huge head ready for a hat. |
| **Rezia** | Wait – wait – how about – there! |
| **Septimus** | A pig at a fair. |
| **Rezia** | It is hopeless! |
| **Septimus** | No, no, come on, she shall have a beautiful hat. What have you got? |
| | Build it up – / first one thing, then another. |
| **Rezia** | First one thing, then another. |
| **Septimus** | There it is – be careful now – it is the hat that matters most! |

| | |
|---|---|
| **Rezia** | Beautiful. |
| | *A knock at the door.* |
| – | Holmes? |
| | ***Rezia*** *goes out.* |
| – | Bradshaw? |
| **Septimus** | Who is it? |
| – | Evans? |
| **Rezia** | *(Off.)* The girl with the paper. |
| – | Thin. The flesh has melted off the world. |
| – | My body is stretched thin – only the nerves are left – spread on a rock. |
| – | I leant over the edge of the boat and fell down. |
| – | Fell down, went under the sea. |
| – | I have been dead. I am now alive. |
| – | Let me rest still. |
| | ***Evans*** *appears.* |
| **Septimus** | Evans? Evans! I am ready. The message – now – what should we do? |
| ***Evans*** | Let me rest... |
| | Let me rest. Let me rest. Let me rest. Let me rest. Let me rest. Let me rest. Let me rest. Let me rest. Let me rest. Let me rest. Let me rest. Let me rest. Let me rest. Let me rest. Let me rest. Let me rest. Let me rest. Let me rest. Let me rest. Let me rest. |

Let me rest. Let me rest. Let me rest. Let me rest.
Let me rest. Let me rest. Let me rest. Let me rest.
LET ME REST –

*Rezia returns.*

**Septimus**   Who was it?

**Rezia**   *(Handing him the paper.)* The paper.

**Septimus**   *(Reading.)* Surrey's all out.

**Rezia**   Surrey's all out.

*Septimus*   Build it up –

*Rezia*   First one thing.

*Septimus*   Then another.

**Septimus**   There's a heat wave.

**Rezia**   I had not noticed. Ah, damn –

**Septimus**   What?

**Rezia**   The needle's broken.

**Septimus**   Surrey's all out. There's a heat wave. The needle's broken.

–   Build it up – first one thing, then another.

**Rezia**   Mio piccolo falco.

–   Her little hawk.

**Rezia**   Come quando ti ho conosciuto per la prima volta.

| | |
|---|---|
| – | Like when she met him for the first time. |
| **Rezia** | We are perfectly happy now. |
| **Septimus** | Yes. It is beautiful. |
| **Rezia** | And you are happy? |
| **Septimus** | Yes. |
| *Proportion* | And the people we are most fond of are not good for us when we are ill. |

*Big Ben strikes 5. The leaden circles dissolve in the air.*

| | |
|---|---|
| **Rezia** | Five already? |
| *Rezia* | They will be here soon. |
| **Septimus** | I must rest. |
| **Rezia** | Yes. |
| **Septimus** | I must rest. |
| | Must. MUST? What right has Bradshaw to say 'must' to me? |
| **Rezia** | Septimus. They will take you to rest only for a while, it is the law – |
| **Septimus** | Holmes's law? |
| **Rezia** | No, no, Sir Bradshaw, no more Dr Holmes – |
| **Septimus** | But he is on me! Human nature is on me. They will tear me to pieces – |
| **Rezia** | Septimus, please. We will be all right. The hat, you must help – |
| **Septimus** | No, no, no. Where are my papers? |

| | |
|---|---|
| **Rezia** | Septimus – |
| **Septimus** | The things I've written? |
| **Rezia** | Please – |
| **Septimus** | Where are they? |
| **Rezia** | Here, in the draw. |

| | |
|---|---|
| **Septimus** | Burn them. |
| **Rezia** | Septimus – |
| **Septimus** | Burn them! |
| **Rezia** | I will not. |

*Septimus* moves to tear the papers up.

**Rezia** No! They are very beautiful. Septimus, if they take you, I will go with you. They cannot separate us against our wills.

Here – look – I will put them back –

*A knock at the door.*

That will be Mrs Peters –

*Rezia* goes out. *Septimus* listens.

**Rezia** *(Off.)* No. No! I am sorry Dr Holmes but we won't be needing / your advice –

**–** Fear no more says the heart in the body.

**Holmes** *(Off.)* My dear lady, I have come / as a friend.

**–** Fear no more the heat of the sun.

**Rezia**       *(Off.)* I will not allow you to see my husband.

**Septimus**    There it is.

–               London has swallowed up many millions of
                young men called Smith.

**Septimus**    Once you stumble, human nature is on you.

–               Thought nothing of fantastic Christian names like
                Septimus with which their parents had thought to
                distinguish them.

–               He did not want to die.

**Septimus**    I do not want to die.

–               And the rather melodramatic business of opening
                the window and throwing himself out? That was
                their idea of tragedy, not his or Rezia's. It was
                their idea of tragedy – Holmes or Bradshaw –
                they liked that sort of thing.

**Septimus**    I do not want to die. Life is good.

–               But then the whole world seems to clamour: kill
                yourself, kill yourself, for our sakes.

**Septimus**    Life is good. Life has a way of adding day to day.

–               And why for their sake? Food is pleasant, the sun
                hot, life has a way of adding day to day... Only
                human beings – what do they want?

**Septimus**    What do you want?

**Rezia**       *(Off.)* I will not allow you to see my husband.

**Holmes**      *(Off.)* You will allow me –

                ***Holmes*** and ***Rezia*** *come into the room.*

*Septimus falls.*

**Holmes**    Coward.

**Rezia**    I saw. I understood.

I was on the stairwell. I was given something to drink – something sweet – was told to lie down – was in some garden. A clock was striking – four, five, six – a sensible sound – went on striking, seven, eight, nine – a sensible sound – and Mrs Peters came in for her hat, her beautiful hat, and she was waving her apron like a flag.

I once saw a flag slowly rippling out from a mast when I stayed with my aunt in Venice. Men killed in battle were saluted in this way – a flag unfurling out at sea.

And Septimus had been through the War. And had been brave.

And – most of my memories are happy.

*We rush forward into the evening – a party builds around* **Rezia** *– a wall of noise growing louder and closer as the following blares out:*

– THE TRIUMPH OF CIVILISATION!

– The brain must wake now.

– # THE TRIUMPH OF CIVILISATION!

– The body must contract.

- # THE TRIUMPH OF CIVILISATION!

- My love to Mrs Walker. – But it is so old fashioned! – Apologies, we are most awfully late!

- # THE TRIUMPH OF CIVILISATION!

- My love to Mrs Walker. – But it is so old fashioned! – Apologies, we are most awfully late! – The Prime Minister is coming. – Was this really made at home? – That must be Hugh Whitbread.

- # THE TRIUMPH OF CIVILISATION!

- My love to Mrs Walker. – But it is so old fashioned! – Apologies, we are most awfully late! – The Prime Minister is coming. – Was this really made at home? – That must be Hugh Whitbread. – How delightful to see you! – Isn't that Elizabeth, in the pink? – The Prime Minister? Here?

- # THE TRIUMPH OF CIVILISATION!

- My love to Mrs Walker. – But it is so old fashioned! – Apologies, we are most awfully late! – The Prime Minister is coming. – Was this really made at home? – That must be Hugh Whitbread. – How delightful to see you! – Isn't that Elizabeth, in the pink? – The Prime Minister? Here? – Do you remember it before the war? – It's odd that you should know one another. – Loved it! Yes!

# THE TRIUMPH OF CIVILISATION!

My love to Mrs Walker. – But it is so old
fashioned! – Apologies, we are most awfully late!
– The Prime Minister is coming. – Was this really
made at home? – That must be Hugh Whitbread.
– How delightful to see you! – Isn't that Elizabeth,
in the pink? – The Prime Minister? Here? – Do
you remember it before the war? – It's odd that
you should know one another. – Loved it! Yes! –
What a fright she looks! – The Prime Minister is
on his way! – India or somewhere, I don't recall.

*The party:*

**Hugh**       The triumph of civilisation!

**Clarissa**   What's that?

**Hugh**       An evening like this, Clarissa, it is the triumph of
               civilisation.

**Clarissa**   Yes! I am so glad, Hugh, so glad you and Evelyn
               could be here.

**Richard**    And, Eliot, dear cousin Eliot –

–              Poor dwindling Eliot Henderson –

–              Who cannot even hold himself straight.

**Richard**    How is the world treating you?

**Eliot**      Very well, yes, thank you, Richard.

–              Are they laughing at me?

| | |
|---|---|
| ***Proportion & Conversion*** | Lady and Miss Lovejoy! |
| **Eliot** | A little hot – I'm just a little hot, but it was so nice of you – so extraordinarily nice of you to invite me, really, and really the heat doesn't matter so much does it, I mean really most people feel the heat more than the cold these days, it seems – to me anyway – |
| **Richard** | Yes, they do. |
| ***Proportion & Conversion*** | Sir John and Lady Needham! |
| **Peter** | Richard Dalloway! |
| **Richard** | Peter Walsh! |
| ***Proportion & Conversion*** | Mr and Mrs Dakers! |
| **Richard** | My God! – Eliot, do excuse us. |
| ***Eliot*** | Really so awfully kind for Clarissa to have thought – to have thought that I should be here, you see, at this event, at all, quite a treat just to see such people, to hear such voices – |
| ***Proportion & Conversion*** | Sir Bowley and Lady Mary Maddox! |
| ***Eliot*** | And for Richard to come all the way across the room and talk to me – |
| **Clarissa** | Eliot! How are you? |
| **Eliot** | Oh dear Clarissa – |
| – | CLARISSA! |
| **Eliot** | Just perfect, thank you – |

| | |
|---|---|
| *Proportion & Conversion* | Lady Bruton! |
| – | LADY BRUTON! |
| **Eliot** | A little hot – I'm just / a little hot – |
| **Clarissa** | Wonderful, Eliot. Wonderful. Do excuse me. |
| – | Clarissa? |
| – | I respect her. – I admire her. – I resent her. – I worship her. – I love her. – I envy her. |
| **Clarissa** | Lady Bruton – it is so delicious of you to have come. |
| **Millicent** | Not at all. |
| **Clarissa** | Richard so much enjoyed your lunch party. |
| **Millicent** | Richard was the greatest possible help with a project of mine. How are you? |
| **Clarissa** | Perfectly well! |
| *Millicent* | I detest illness in the wives of politicians. |
| **Clarissa** | Yes, very well, thank you. |
| **Millicent** | And there is Peter Walsh. |
| **Clarissa** | Yes, you must talk to him – about Burma, he has been in Burma. Peter! |
| **Peter** | Good evening, Lady Bruton. |
| **Millicent** | Good evening, Mr Walsh. Fresh from the centre! What a tragedy it is! |
| *Proportion & Conversion* | Mrs Hilbery and Mrs Parry. |

**Clarissa**      It is going to be a failure, a complete failure.

**Mrs Hilbery**   Dear Clarissa!

**Clarissa**      Mrs Hilbery!

**Mrs Hilbery**   You look so like your mother as I first saw her at Bourton.

**Clarissa**      How wonderful to see you.

*Clarissa*      Might it all consume me anyhow?

**Mrs Hilbery**   I could not have missed it.

–      The truth? It is tiring, it is noisy, it is hot, but Clarissa had asked her.

**Mrs Hilbery**   I do love society.

–      Clarissa had asked her. So she had come up with Aunt Helena.

**Mrs Hilbery**   And London!

–      It is a pity they lived in London – Richard and Clarissa.

**Mrs Hilbery**   You look very well.

–      If only for Clarissa's health it would have been better to live in the country.

**Clarissa**      Thank you, yes, I feel it.

*Proportion*    Sir Harry!
*& Conversion*

**Clarissa**      Dear Sir Harry!

**Mrs Hilbery**   Enjoy your evening, Clarissa!

| | |
|---|---|
| **Clarissa** | Yes – and you! |
| **Harry** | Oh Clarissa! Look at you! |
| – | Clarissa? |
| – | Did well. – Meant well. – Not enough. – A success. – A snob. – A good heart. |
| – | The perfect hostess! |
| **Clarissa** | What are you laughing at? |
| *Harry* | Simply how much these circles are above me! |
| **Harry** | Oh, Clarissa, one never knows. |
| **Clarissa** | You are absurd! |
| **Harry** | Is Herbert here yet? |
| **Clarissa** | Yes, through there. |
| **Harry** | Marvellous. |
| *Clarissa* | Burn me to cinders – it will be a failure! |
| *Proportion & Conversion* | The Prime Minister! |
| – | The Prime Minister! |
| *Peter* | Well, well, the Prime Minister – poor chap. |
| *Eliot* | What a thing to tell father! |
| *Millicent* | I shall have a word with him. |
| *Hugh* | This majesty passing! |
| *Peter* | Lord, lord, the snobbery of the English. |

89

| | |
|---|---|
| **Richard** | It is so good of you to come. |
| **Clarissa** | Do allow me to show you round. |
| – | Clarissa? |
| – | Tender. – Severe. – Prudish. – Wooden. – Cold. – Beautiful. – Dignified. – Difficult. |
| **Elizabeth** | The Prime Minister? He looks so ordinary. You might stand him behind a counter and buy biscuits from him… One wants to laugh at him! One wants to laugh at all of this! How much nicer to be in the country and do what I like. And already I can feel it beginning – people looking, staring, comparing me to things – |
| – | She is like a poplar – |
| – | Like a hyacinth – |
| – | Like a river – |
| – | Like a cool glade – |
| *Elizabeth* | It is beginning. Miss Kilman has warned me and it is beginning. |
| **Harry** | And how are you Elizabeth? |
| **Elizabeth** | Quite alright, thank you – though I had hoped we'd have dancing! |
| **Harry** | What a pity! |
| **Elizabeth** | And all this noise is something – |
| **Harry** | The sign of a successful party! |
| **Elizabeth** | I suppose you're right! |

| | |
|---|---|
| *Proportion & Conversion* | Lady Rosseter! |
| *Clarissa* | Lady Rosseter? Who on earth is Lady – |
| **Sally** | Clarissa! Where is Clarissa? |
| – | That voice – which makes everything sound fantastical – |
| – | That voice – that laugh – holding her from across the room and reassuring her on a point – |
| – | Which sometimes bothers her if she wakes early in the morning and lies alone – |
| – | How it is certain we must die. |
| **Peter** | Sally! |
| **Sally** | Peter! Thank Christ you're here! |
| **Peter** | I very nearly wasn't. |
| **Sally** | I thought you were still away? |
| **Peter** | Today is my first day back in London. |
| **Sally** | Well God I am glad to see you. And here is Clarissa! |
| **Clarissa** | Sally! |
| **Sally** | I know, I know, here I am without an invitation – |
| **Clarissa** | But I didn't know you were in town. |
| **Sally** | Only for the week. |
| **Peter** | Where do you live now? |

| | |
|---|---|
| **Sally** | Manchester. But I was in town and heard you were giving a party and I couldn't *not* come – so, here I am. |
| **Clarissa** | How wonderful. |
| ***Proportion & Conversion*** | Sir and Lady Bradshaw! |
| **Clarissa** | Listen, I can't stay – I shall come back – but wait. |
| **Lady Bradshaw** | We are shockingly late, dear Mrs Dalloway, we hardly dared to come in! |
| **Bradshaw** | But we were not able to resist the temptation! |
| **Clarissa** | I am so pleased you did, Sir William. How is your son at Eton? |
| **Lady Bradshaw** | Unfortunately he just missed his eleven – |
| **Bradshaw** | The mumps got him! |
| **Lady Bradshaw** | Well, his father minds more than he does, since he's nothing but a great big boy himself! |
| **Richard** | Sir William! How good to see you. |
| **Bradshaw** | Terribly late, I know. |
| **Lady Bradshaw** | You see, just as we were starting out, we got a call, a very sad case – |
| **Bradshaw** | A young man had killed himself. |
| ***Clarissa*** | Here's death at my party. |
| **Lady Bradshaw** | Yes – terrible, really. |

92

| | |
|---|---|
| *Clarissa* | What business have they to talk of death at my party? |
| **Lady Bradshaw** | Had been in the army, is that right? |
| **Bradshaw** | That's right. |
| *Clarissa* | He has killed himself. |
| **Bradshaw** | Served with the greatest distinction. |
| *Clarissa* | But a thing that mattered – |
| **Lady Bradshaw** | Sadly this evening – |
| *Clarissa* | There is a thing that matters – |
| **Lady Bradshaw** | Threw himself from a window. |
| *Clarissa* | He threw it all away. |
| **Bradshaw** | I had reviewed his case only this afternoon. |
| | |
| *Clarissa* | *You* forced his soul. |
| **Bradshaw** | His wife was the sweetest woman. Italian – |
| *Clarissa* | You are capable of forcing a soul. |
| **Lady Bradshaw** | But these things happen – |
| *Clarissa* | Life is made intolerable. |
| **Lady Bradshaw** | You know. |
| *Clarissa* | Life is made intolerable by men like you. |

| | |
|---|---|
| **Richard** | Of course, yes. |
| | |
| **Clarissa** | Do excuse me. |
| **Hugh** | Clarissa? |
| **Clarissa** | One moment, Hugh. |

*Clarissa leaves the party. **Septimus** follows her upstairs:*

– Fear no more the heat of the sun, says the heart in the body.

– Fear time itself – withdrawing, collapsing, year by year.

– Like a nun withdrawing, or a child exploring a tower, she goes upstairs.

– Fearing the emptiness about the heart of life – an attic room.

*Clarissa* Always my body goes through it first. 'He had thrown himself from a window' and no sooner do I hear that – up, up flashes the ground and through me go the rusty spikes and I lie there with a thud, thud, thud in my brain, and then a suffocation of blackness.

And somehow, I think now that it is my disaster – my disgrace.

I have lied. I have schemed. I have stolen. I have envied. I have wanted success. I am never wholly admirable. But I will go on living. I will grow old. That is a disgrace.

**Septimus**  Did you not say to yourself once, coming down, in white, in the evening for dinner – 'If it were now to die, 'twere now to be most happy'?

**Clarissa**  I did.

**Septimus**  And you meant it?

**Clarissa**  I did, yes. I meant it then.

**Septimus**  There is a thing that matters – hidden in chatter, defaced, obscured every day in corruption and lies – there is a thing that matters, somewhere at the heart of life.

**Clarissa**  But it is too much.

**Septimus**  It is terrifying.

**Clarissa**  This thing, one's parents giving it into one's hands, this life, to be lived to the end. It is too much.

And you have killed yourself.

*Septimus nods. Looking out the window:*

**Septimus**  Who's that?

**Clarissa**  The old woman opposite. I don't know her name.

**Septimus**  Going to bed alone.

*Clarissa nods.*

*Big Ben strikes 11. The leaden circles dissolve in the air.*

*Clarissa* and *Septimus* *stand together – they look out at the old woman in silence.*

| | |
|---|---|
| *Clarissa* | And the sky – there it is, turning darker still now – but I must go back. |
| | I must go back down. |
| *Septimus* | Does she pity him? |
| *Clarissa* | No. He has – preserved it. There is a thing that matters somewhere at the heart of life. And he has preserved it. |
| *Septimus* | And you must go back to the fun and the beauty. |
| *Clarissa* | Yes. |
| *Septimus* | You must find Sally and Peter. |

*Return to* **Sally** *and* **Peter** *– waiting for her:*

| | |
|---|---|
| **Peter** | But where has she got to? |
| **Sally** | She is with some people of importance she has to be nice to – did you think these parties were for old friends? |
| **Peter** | I only recognise half the people here from the papers. |
| **Sally** | And since I scarcely read the papers I don't recognise a soul. I live quite the solitary life these |

days, Peter, 'in the wilds', as Clarissa would say
– if it wasn't for my five sons – well, I might have
nothing at all to do.

**Peter**      And who is your Lord Rosseter?

**Sally**      You would like him, I think. He's terrifically /
reliable –

**Peter**      Wealthy?

**Sally**      Peter!

**Peter**      Clarissa wrote a little about him – myriads of
servants, acres of land, miles of conservatories, I
believe it was –

**Sally**      Hah! Yes! I have ten thousand a year! Before or
after tax, I can't remember.

**Peter**      You used to be in rags and tatters.

**Sally**      Oh not quite, not quite.

Who is that?

**Peter**      That? That is Elizabeth.

**Sally**      Goodness – not a bit like Clarissa.

**Peter**      No.

Oh, where is she?

**Sally**      She will come.

And there is Hugh Whitbread – should we hide?

**Peter**      He's not going to recognise us!

**Sally**      What does he do?

| | |
|---|---|
| **Peter** | Counts the bottles at Windsor – |
| **Sally** | Buffs the King's boots – |
| **Peter** | Straightens the Prince's ties! Sally, that kiss now, Hugh's – |
| **Sally** | On the lips, in the smoking-room. |
| **Peter** | Really? |
| **Sally** | Yes. Horrible! And now he must have six sons at Eton. |
| **Peter** | Everybody here has six sons at Eton. |
| **Sally** | Have you any children? |
| **Peter** | No, thank God, none. No sons, no daughters, no wife. |
| **Sally** | Well, you don't seem to mind. |
| **Peter** | I don't much. |
| **Sally** | And you look younger than any of us. |
| | Have you written? |
| **Peter** | Not a word! |
| **Sally** | It's not too late. |
| **Peter** | It is, it is much too late. |
| **Sally** | Perhaps you're right. |
| | Oh – you must come down to see us in Manchester. |
| **Peter** | I would love to. I will. |

| | |
|---|---|
| **Sally** | Really. You should stay with us for weeks and weeks! As long as you like. |
| **Peter** | As long as I dare! |
| **Sally** | Yes! |
| | Of course, I've asked Clarissa a dozen times over the years and has she ever come? |
| **Peter** | I will come – I will. |
| **Sally** | And bring her with you. |
| **Peter** | Who? |
| **Sally** | Clarissa! I shall ask her again tonight. I shan't give up! God, I owe her so much. D'you know – to this day blue hydrangeas make me think of Bourton? Honestly! You will think me sentimental, but I think of Bourton always, and sometimes at night when I count up my blessings I put her friendship first – I know it *is* sentimental! But I have come to feel that it is the only thing worth saying – what one feels. Cleverness is silly. One must simply say what one feels. |
| **Peter** | But I do not know what I feel. Life has not been simple. My relations with Clarissa have not been simple. |
| **Sally** | No. |
| **Peter** | One cannot be in love twice. |
| **Sally** | But all the same it is better to have loved – it is better. And I know you will think that sentimental. Dear Peter – you must promise to come and stay. |
| **Peter** | I promise. |

| | |
|---|---|
| **Sally** | Good. And now Clarissa must as well. Where the devil is she? |
| **Peter** | Talking, talking, talking. |
| **Sally** | And how did she do it? |
| **Peter** | What? |
| **Sally** | This! All this. How did she do it? |
| **Peter** | She married him. |
| **Sally** | Yes. No but she cared for you more than she ever cared for him. Who is he talking to? |
| **Peter** | A damnable humbug of some kind. |
| **Sally** | He has a good heart – |
| **Peter** | Richard? |
| **Sally** | Yes. |
| **Peter** | Yes. He has improved. |
| **Sally** | A good heart, really. I should speak to him. |
| | Write to me, Peter – and we shall have you to stay soon. |
| **Peter** | I will. |
| **Sally** | I shall go and say goodnight. What does the brain matter, compared with the heart? |
| – | What is this terror? |
| – | What is this ecstasy? |
| – | What is it that fills me with extraordinary excitement? |

**Peter**      It is Clarissa.

–          He said.

–          For there she was.

**The End.**

WWW.OBERONBOOKS.COM

Follow us on www.twitter.com/@oberonbooks
& www.facebook.com/OberonBooksLondon